CARDIFF
IN
50
BUILDINGS

JOHN B. HILLING &
DAVID A. L. HILLING

AMBERLEY

First published 2018

Amberley Publishing, The Hill, Stroud
Gloucestershire GL5 4EP

www.amberley-books.com

British Library Cataloguing in Publication Data.
A catalogue record for this book is available from the British Library.

ISBN 978 1 4456 6814 7 (print)
ISBN 978 1 4456 6815 4 (ebook)

Origination by Amberley Publishing.
Printed in Great Britain.

Contents

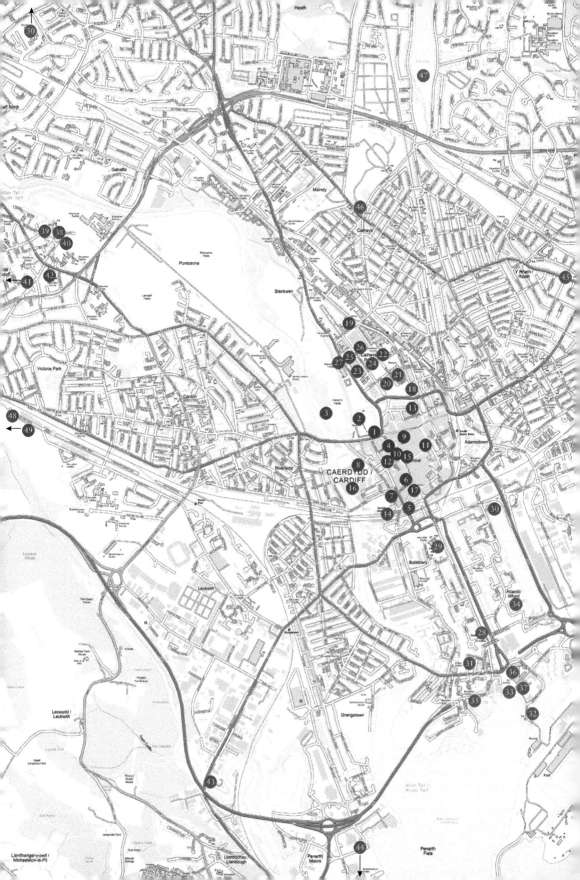

Key

Introduction

Cardiff, capital of Wales, is largely the product of the nineteenth and twentieth centuries. Even so, its roots lie in the distant past. The Romans were the first to appreciate the potential of the site next to the River Taff as the key to routes to the west and north. They erected their first wooden fort at this crossing in around AD 60. Their fourth and strongest fort was built around AD 280; it is the remains of this fort that can be seen embedded in later masonry. As the Roman Empire began to disintegrate, the fort was abandoned early in the fifth century and, as far as is known, was not used again until the eleventh century when it became the basis for a Norman castle.

The small civil settlement of Caerdyf that had grown up outside the walls of the Roman fort may well have survived in some rudimentary form, though after

Roman walling embedded in later masonry at Cardiff Castle.

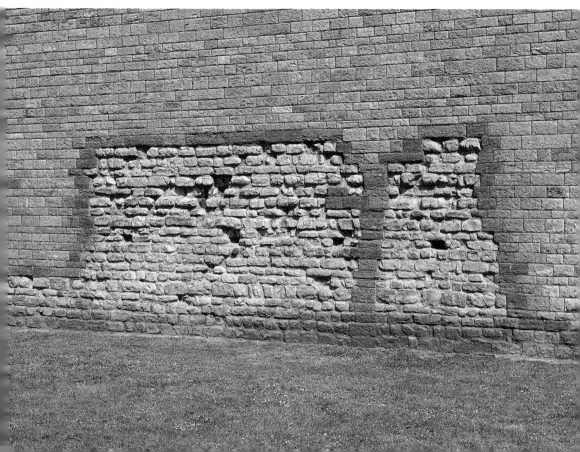

the Roman departure there was comparatively little organised commerce. But this does not mean that all vestiges of civilisation in the area had been relinquished. Indeed, it was during this period, when Saxon England was still heathen, that the early Christian Cymry (Welsh) established an important monastery in the sixth century at Llandaf, 2 miles upriver from the castle.

The actual founding of Cardiff as a borough took place at the end of the eleventh century, either when William the Conqueror (or 'William the Bastard' as he was referred to in the Welsh Chronicles of the Princes) returned from a pilgrimage to St David's in 1081 or in 1091 when the Normans, under Robert Fitzhamon, invaded the area and raised Cardiff Castle within the remains of the Roman fort.

The castle became the centre of Anglo-Norman administration in the area, which, as a Marcher lordship, remained virtually independent for much of the medieval period. The borough was laid out in burgages (building plots) and defensive walls were erected. The priory church of St Mary was established by around 1100, followed by St John's Church soon afterwards. By the end of the thirteenth century Cardiff was the largest borough in Wales, with more than 400 burgages and a population of around 2,000 people.

Meanwhile, Llandaf – then a borough in its own right – continued to develop on the opposite side of the river. A new cathedral was begun there in 1120 in Romanesque style by Urban, the first Norman bishop, only to be rebuilt fifty years later in Gothic style. A fortified castle or palace was erected nearby during the next century for a later bishop.

The sixteenth century brought far-reaching changes to the area that marked the end of the medieval period. With an Act in 1536 the properties of Cardiff's two monastic houses (Black Friars and Grey Friars) were confiscated. Under the terms of further Acts in 1536 and 1543 Wales became 'united' with England, and Cardiff emerged as a 'free' borough with representation at the Westminster Parliament.

By 1610, when John Speed mapped the boroughs of Cardiff and Llandaf, their street layouts were recognisably similar to those today. Cardiff was now in decline, as George Owen hinted at when describing Cardiff in 1602 as 'the fairest towne in Wales yet not the wealthiest'. The River Taff, ever changing its course, had moved away from the castle but closer to St Mary's Church, threatening its fall. Progress was slow and it was not until the 1780s that three of the gates into the small, sleepy town were taken down.

A few years later, in 1794, the situation changed almost overnight when a 25-mile-long canal linking Merthyr Tydfil – by then the largest town in Wales and chief centre of the iron industry – to Cardiff was opened. The canal provided an easy and comparatively quick way of transporting iron down the Taff Valley so that it could be shipped from Cardiff to London and other places. By 1817 the amount of iron shipped from Cardiff was 30,000 tons, and by 1830 it had risen to 66,000 tons.

Soon, coal was beginning to vie with iron for export, with the result that traffic was becoming bottlenecked at the port end. In order to relieve the pressure, the 2nd Marquess of Bute – chief landowner in and around Cardiff – had the first dock built in 1839. To facilitate the transport of iron and coal more efficiently, the Taff Vale Railway was constructed from Merthyr Tydfil to Cardiff in 1840–01. Further railways and docks followed, and coal soon overtook iron in exports. By 1871 the annual amount of coal exported had grown to more than 2 million tons and Cardiff's population had risen to more than 57,363 people, making it, once again, the largest town in Wales.

Cardiff's population continued to grow rapidly. By 1901 it had risen to more than 164,000 people, and its annual coal exports amounted to 7.5 million tons – making it the largest coal port in the world. The borough's boundaries were extended in 1875, but despite this there was still insufficient land to contain its burgeoning population or to provide space for its outdated public buildings. It was only after prolonged negotiations with the 3rd Marquess of Bute and his agents that the council was able to purchase Cathays Park in 1898 to erect long-needed public buildings. The first of these, the City Hall and Law Courts, were opened in 1905. Six more civic buildings – including the National Museum and the university – were begun before the First World War brought construction work to an abrupt halt.

Cardiff continued to grow during the twentieth century, increasing its population to 300,000 by the end of the century and enlarging its area to include

The Civic Centre, 1981.

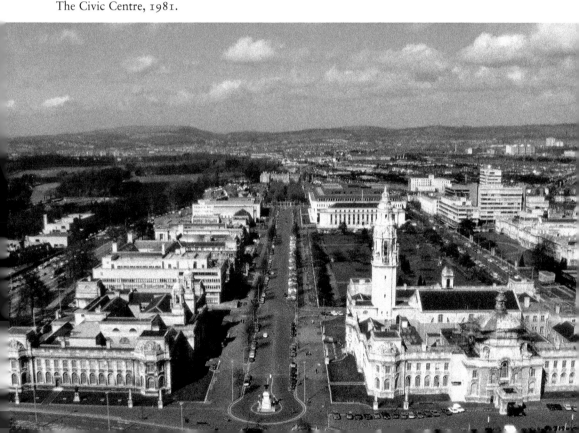

the ancient city of Llandaf and other surrounding parishes. Efforts to underline Cardiff's importance as the chief urban centre in Wales continued unabated. Further public buildings were erected in Cathays Park, making it 'the finest civic centre in Britain'. In 1955 Cardiff became the official capital of Wales. Fifty-four years later, in 1999, it became home to the National Assembly of Wales, following a referendum two years earlier that resulted in a majority in favour of devolutionary powers for Wales.

The 50 Buildings

The City Centre

1. Cardiff Castle – The Roman Fort

The Romans built their first fort here in around AD 55, on the site of what was later to become Cardiff Castle, near the crossing of the River Taff. The quadrangular fort was very large and constructed of earthen banks with timber buildings. The first fort was short-lived, for once the surrounding area had been subdued it was replaced in around AD 75 by a much smaller fort. This was followed fifty years later by a third earth-and-timber fort on the same site. A growing threat from Irish sea raiders in the third century AD led to the construction of a fourth, strongly built fort in around AD 280.

Reconstructed walls of the Roman fort, Cardiff Castle.

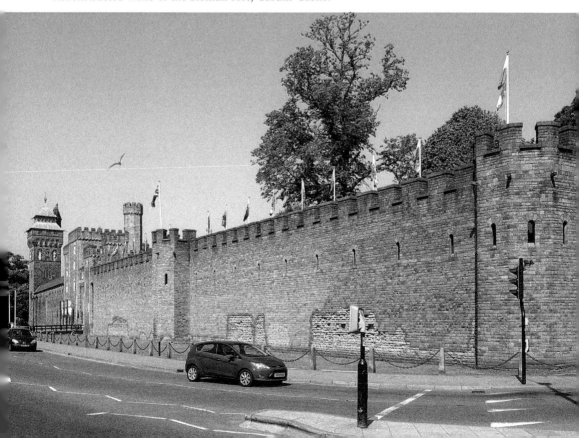

The 3-metre-thick stone curtain walls were backed by great earthen banks and enclosed an area of 3.5 hectares. During the early fourth century, the fort was strengthened by replacing the curtain wall's rounded corners with angular corners and by adding five-sided towers to the outer faces of the walls, with paired towers at the north and south gates. The Roman Empire began to disintegrate in the late fourth century, and by the end of the century the fort by the Taff had been abandoned. The fort must have gradually fallen into ruins and became overgrown and was all but forgotten by the time that the Normans arrived in the late eleventh century.

It was not until 1889 that remains of the Roman fort walls were rediscovered during archaeological excavations. Lord Bute had the surviving walls repaired; at the same time the missing parts of the walls and the north gate were reconstructed. From the outside, it is mostly the rebuilt walls that we see today, with parts of the original Roman walls outlined in red stone. Bute also constructed an underground gallery behind the walls, from which the inner face of the south wall of the Roman fort can now be seen. The restored walls, though higher than those originally built, give a good impression of the appearance of a late Roman fort.

Reconstructed North Gate of the Roman fort, Cardiff Castle.

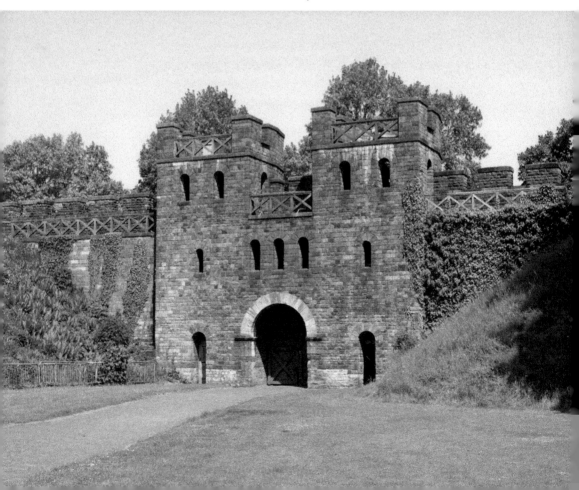

2. Cardiff Castle – Norman and Later Buildings

When the Normans invaded the area towards the end of the eleventh century they used the ruined walls of the Roman fort as the basis for their new castle. They built a Great Tower in wood on an earthen motte surrounded by a circular moat at the north-west corner. The timber tower was insufficient defence against the native Welsh, however, for in 1158 Ifor ap Meurig, Lord of Senghenydd, attacked the castle at night and, using ladders to scale the walls, seized hold of the Norman earl, his countess and their small son. He then carried them off to the woods and refused to release them until his stolen possessions were returned.

The wooden Great Tower was rebuilt in stone at the end of the twelfth century as a handsome, twelve-sided shell keep. A gatehouse was added to the keep in the thirteenth century by Gilbert de Clare, and during the same period, the castle was further strengthened by rebuilding the south gate and erecting the adjoining Black Tower. A stone wall was built to link the Black Tower to the keep, thus dividing the outer castle into inner and outer courts.

As times became more settled in the fourteenth century, the keep ceased to be used and a range of residential buildings – that included a Great Hall and an octagonal Beauchamp Tower – were built alongside the west wall. The rectangular Herbert Tower was added to these during the following century.

The Norman motte and keep tower, Cardiff Castle.

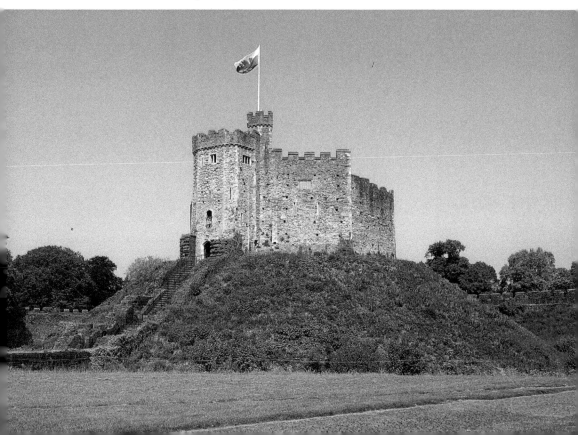

In 1777 the west wing was transformed into a luxurious mansion when 'Capability' Brown, the famous landscape gardener, and his architect son-in-law Henry Holland were engaged by the 1st Marquess of Bute to extend the Great Hall. They also added the Bute Tower on the park side in order to create symmetrical elevations on both sides of the wing.

The biggest changes came during the nineteenth century when the fabulously rich 3rd Marquess of Bute employed William Burges to 'restore' the castle in 1868. Burges added a spiky fleche to the Beauchamp Tower, a steeply pitched roof with tall chimneys to the Herbert Tower and a roof garden with a fountain to the Bute Tower. As the piece de resistance he added a splendid 120-foot-high clock tower at the south-west corner of the castle. Inside the towers Burges created exotic, richly decorated rooms. Finally, he split the Great Hall into two, the lower part becoming a library and the upper part a magnificent Gothic-style banqueting hall with a vaulted hammer-beam roof.

During the Second World War tunnels within the medieval curtain walls were used as air-raid shelters. In 1947, after the death of the 4th Marquess, the castle and park were gifted to the city. A large complex – including an interpretation centre, military museums, Roman wall viewing area and a café – was added in 2008 by partly building into the south bank of the courtyard.

West wing of Cardiff Castle from Bute Park.

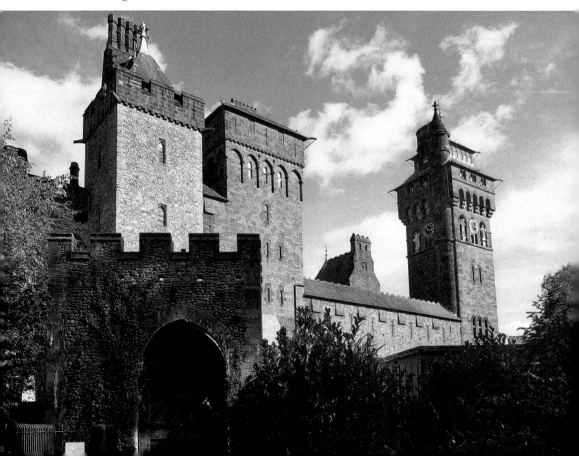

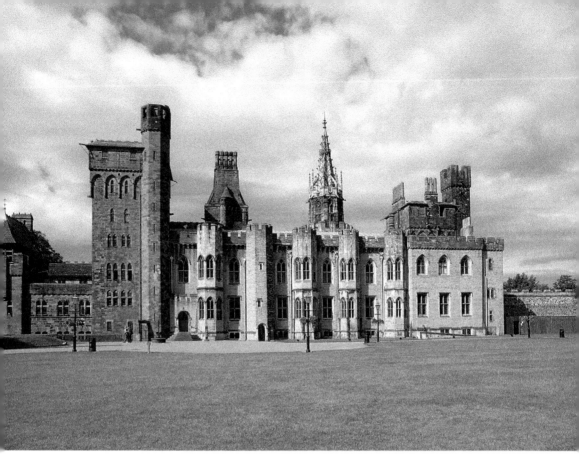

Above: West wing of Cardiff Castle from Castle Green.

Right: The Clock Tower, Cardiff Castle.

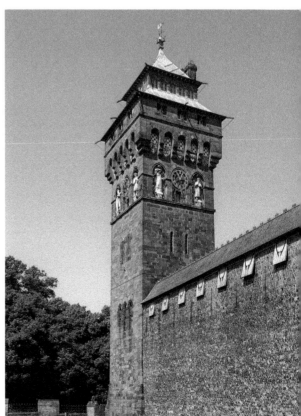

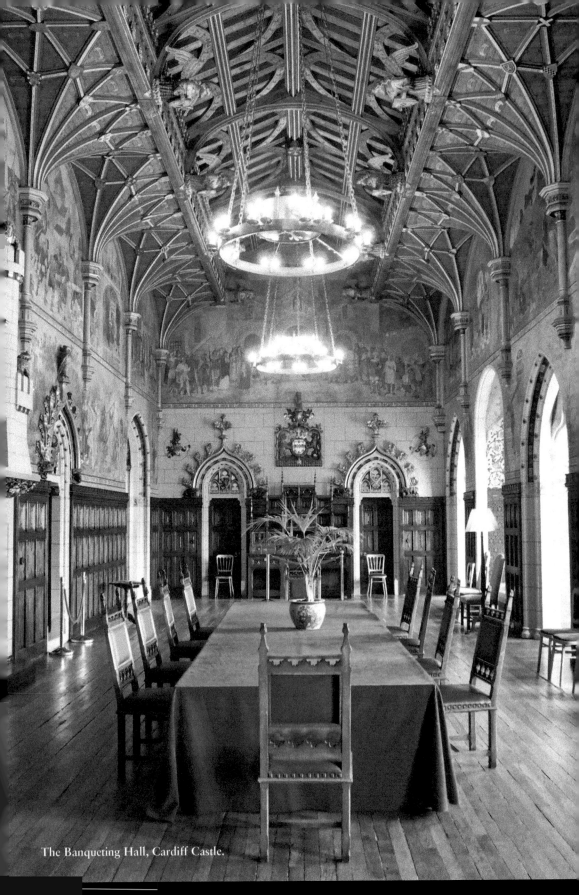

The Banqueting Hall, Cardiff Castle.

3. Blackfriars, Bute Park

Of Cardiff's two friaries, only the foundations of the Blackfriars in Bute Park remain, west of the castle and the river. The friary was erected in 1242 by the Dominicans, or Black Friars as they were known, probably as a series of wooden buildings. By the fourteenth century it had been rebuilt in stone with decorative tiled floors and continued in existence until the Dissolution of the Monasteries in 1536. After the buildings had fallen into ruins, the site was occupied by a house until the early nineteenth century. The site was excavated by the 3rd Marquess of Bute in 1887–88, and the plan of the church and domestic quarters were later marked out by low brick walls with tiled floors.

The church was around 135 feet long and had a short nave of four bays, north and south aisles and a fairly long choir and presbytery. On the north of the church there was a large cloistered court with a chapter house and library on the east side and a common room (with dormitory above) and refectory on the north side. Beyond these were the kitchen, storehouses and infirmary. Nearby is an all-weather model of the friary, showing it as it might have been during its heyday.

The other friary, erected in around 1270 by the Franciscan order of Greyfriars, was built to the east of the castle, in what is now Greyfriars Road. The Franciscans

Remains of Blackfriars Friary.

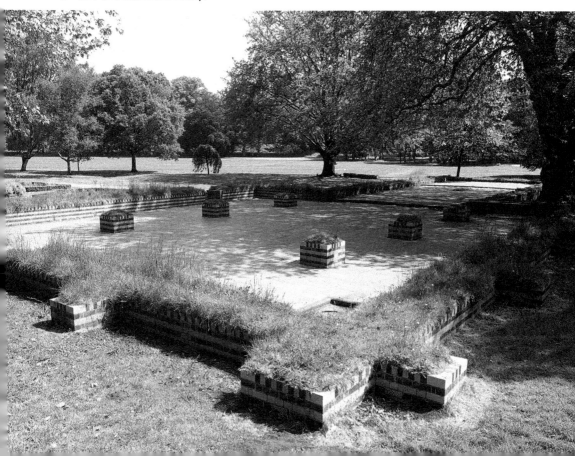

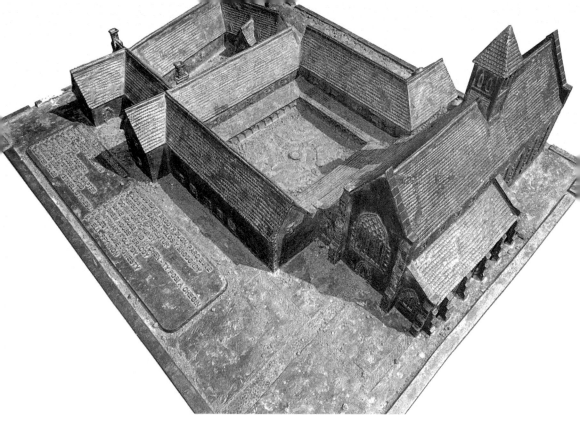

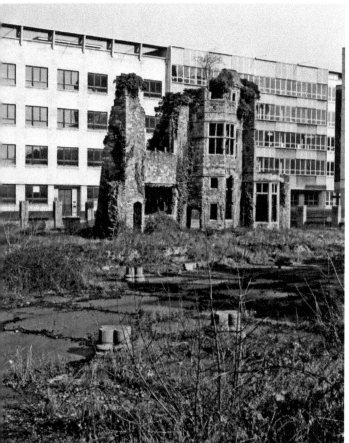

Above: A model of Blackfriars
Friary, as it might have looked in
its heyday.

Left: The remains of Greyfriars
Friary and Herbert mansion,
1967.

were apparently friendly towards the Welsh, so much so that Llywelyn Bren – leader
of a Welsh revolt in 1316 – was buried in the friary in 1318 after being executed
as a traitor by the Anglo-Normans. It was largely due to the friars' sympathetic
attitude that the friary was spared in 1404 when much of Cardiff was burnt and
ravaged by Owain Glyndwr in his bid for Welsh independence. Sir William Herbert
used some of the friary stonework to build a splendid mansion in around 1582.
The remains of the friary and the Herbert mansion were excavated by Lord Bute in
1892–96 and the lower walls and piers of the church laid out to view.

Unfortunately, the remains of friary and mansion were lost once again in
1967, when a multistorey office block (Capital Tower) was built in an act of
environmental folly on the site.

4. St John's Church, St John's Street

The parish church of St John the Baptist is the only medieval church in the city
centre. Though probably founded in the early twelfth century, nothing remains of
the original church. The earliest record of it is from the late twelfth century when
it was a chapel of ease to St Mary's Church at the lower end of St Mary Street. The
earliest parts now visible are early thirteenth-century arches on the south side of
the chancel. In 1453, the church was almost completely rebuilt with Perpendicular
nave arcades incorporating slender piers and a barrel-vaulted ceiling, possibly
following damage earlier in the century during the Glyndwr rebellion. Twenty
years later, the superb 130-foot-high tower – now the glory of the church – was
added following a commission by Anne, wife of Richard III. The tower built by
John Hart in graceful Perpendicular style, has three stages and is topped by an
exquisitely detailed openwork parapet and delicate lantern pinnacles. The main
entrance to the church is through elegant ogee arches forming a porch at the base
of the tower.

As St Mary's Church declined due to its position next to the river, so St John's
Church gradually grew in importance, eventually succeeding the earlier one as
Cardiff's parish church. In 1813, the church was restored and galleries installed,
but these were removed in 1889–91 when the chancel was raised in height and
two outer aisles were added.

The most interesting pre-Victorian part inside is the Herbert Chapel, which is
separated from the chancel by a carved oak screen. It has a seventeenth-century
Jacobean monument to the Herbert brothers (Cardiff's chief family before the
coming of the Butes) and stained-glass windows containing shields of the lords
of Cardiff Castle. The gilded figures of the reredos behind the high altar are by
Goscombe John and the reredos in the south aisle chapel and the east window
are by Sir Ninian Comper. There is a good collection of stained glass, including
some by William Morris, Ford Maddox Brown and Burne-Jones, and a beautiful
modernist Burma Star window was installed in the north aisle in 1986.

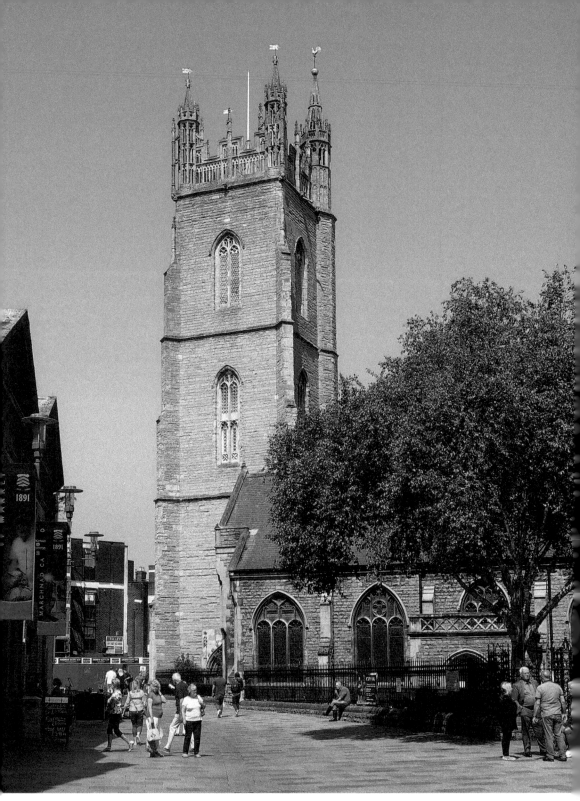

St John's Church, from Trinity Street.

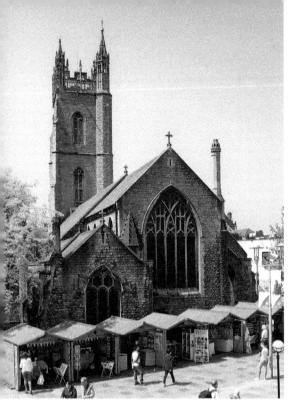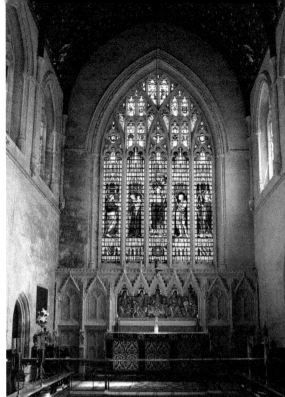

Above left: St John's Church, from Working Street.

Above right: St John's Church – the reredos and east window.

5. Former Custom House, Customhouse Street

As far back as 1550, William Herbert, Earl of Pembroke, had been given the right to levy customs in Cardiff, except on leather goods (and probably woollen goods) that were the responsibility of the Crown. During the seventeenth and eighteenth centuries there was a customs officer in Cardiff, one of whose main duties was to report on smuggling that had become rife on the Welsh side of the Severn Sea (Bristol Channel). By the 1760s there was a Custom House in St Mary Street, but after the opening of the Glamorganshire Canal it was moved nearer to the canal.

A new purpose-built Custom House, probably designed by Sydney Smirke, was erected at the corner of East Canal Wharf in 1845. This was a modest two-storey stuccoed building in rather crude Palladian dress. The rendered upper floor is plain, with tall windows set in blank round-headed arches while the ground floor has windows set in rusticated plasterwork. The main entrance, which faced the canal (now filled in and converted to a road), includes a doorway between paired pilasters supporting a segmental arch. The building was extended in identical style along Customhouse Street in 1865, and again in 2005 (by architects Hoggett Lock-Necrews as the home of the Land Authority for Wales).

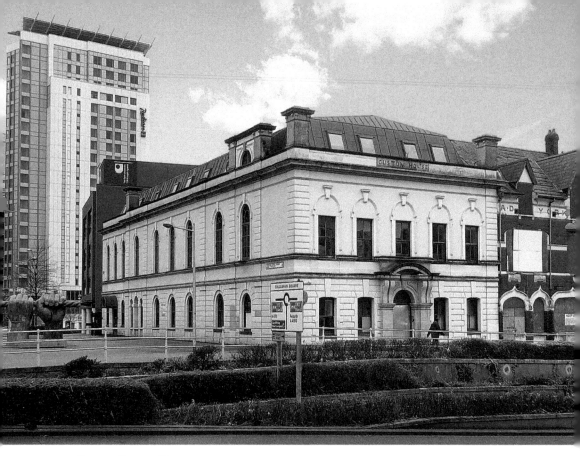

Former Custom House.

In 1898 a new Custom House, designed by Henry Tanner, was built nearer to the docks in West Bute Street. At present the former Custom Hose lies derelict, its future unclear.

6. Capel Tabernacl, The Hayes

The history of Capel Tabernacl goes back to 1813 when Welsh-speaking members of Cardiff's first Nonconfomist chapel (Bethany Baptist, opened 1807) decided to form a Welsh Baptist cause and hold their meetings in a room in the Globe tavern on the corner of Womanby Street. Eight years later in 1821 the Welsh Baptists built their own chapel (Capel Tabernacl) in The Hayes. This was a simple whitewashed building set in its own burial ground. It was here that the great Christmas Evans preached between 1828 and 1832 – he was one of the giants of the Welsh pulpit during its 'golden age'.

By 1842 the chapel had become too small for its congregation and a new chapel was built on the same site. The new chapel was well attended, for when a census of religious buildings was held in 1851, Tabernacl was recorded as having an average evening attendance of 850 people. In appearance the building was very much in

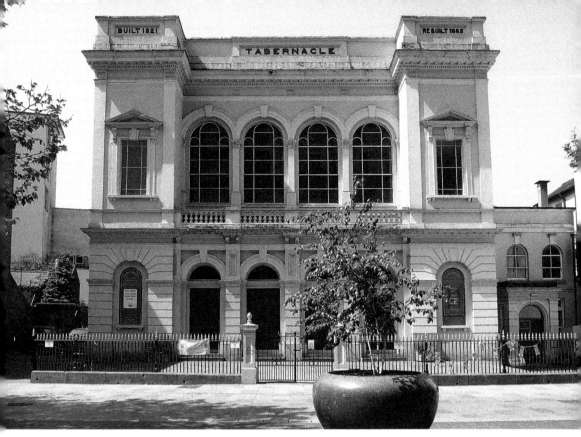

Capel Tabernacl.

the Nonconformist tradition, with the usual name plaque centred in the triangular pediment above the front gable wall.

In 1865, the chapel was enlarged to hold 1,200 people and was refronted in a neoclassical style by John Hartland to become one of Cardiff's finest and most original chapels. The rusticated ground floor, with its range of four round-headed doors in the centre and open stone balustrade above, forms a podium to the set back upper floor with its four great windows between Corinthian pilasters echoing the rhythm of the doors below. On either side are projecting staircase wings with pediments above the upper windows.

The chapel has a handsome interior, with a continuous all-round gallery, a coffered ceiling with circular rose in the centre, and fine stained-glass windows with copies of paintings by Da Vinci (*The Last Supper*) and Goodwin Lewis (*The Baptism of Jesus*).

7. Former Prince of Wales Theatre, St Mary Street

The theatre began life in October 1878 as the Theatre Royal. It was renamed the Playhouse in 1920 after being closed during the First World War, and as the Prince of Wales Theatre after the Second World War. It was finally closed as a

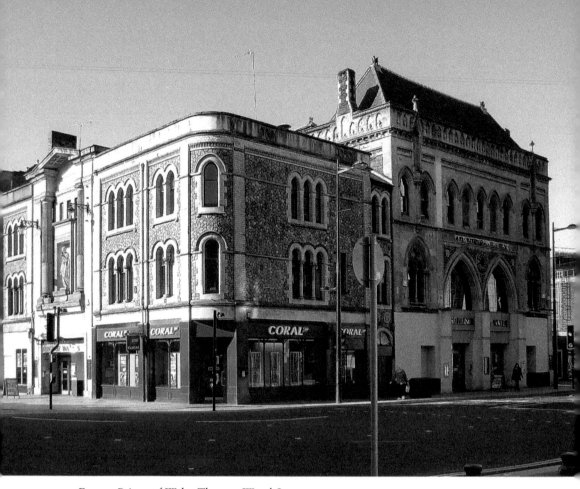

Former Prince of Wales Theatre, Wood Street.

theatre in 1987. Designed in Venetian Gothic style by Walter D. Blessley and T. Waring, its main entrance faced Wood Street. After many years of disuse this entrance was reopened after its conversion to a restaurant, so that the pointed arches above the doorways could be seen once more (but unfortunately without their decorated spandrels). Above the arches there is a row of narrow pointed windows, and to the bays on either side, a mixture of single- and two-light pointed windows.

After its closure during the First World War, the theatre was enlarged and revamped by Willmott & Smith to provide a seating capacity for 1,000 people. It was then that the main entrance was moved to St Mary Street, its façade treated in Greek Revival style with giant Doric columns and a female statue above the doorway.

The auditorium was reconstructed in similar Greek Revival style with the stage flanked by giant Ionic columns supporting a broken pediment and a Grecian frieze in bas-relief. When the building was reopened in 1999 as a restaurant, just enough of the interior remained to give some impression of the theatre's former glory.

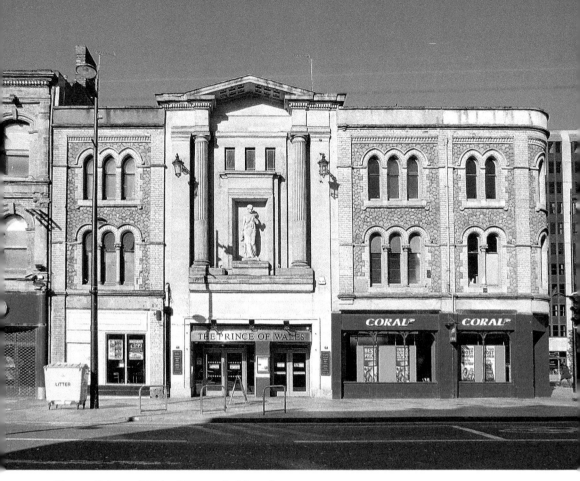

Former Prince of Wales Theatre, St Mary Street.

S. Jackson Hall, Westgate Street

Now the home of the Welsh Rugby Union's shop (WRU Store), the Jackson Hall was built in 1878 as a racquets and fives court. Designed by George Robinson in the style of a large Swiss chalet, it is constructed in multicoloured brickwork – mostly red, but also black- and cream-coloured Bath stone. A blind arcade of four tall and slightly recessed pointed panels enclose modern rectangular windows at ground-floor level with decorative six-part circular windows within the arches. Above is a gallery with a brick balustrade. Arising from this is a tall freestanding flue, off which spring wooden arches to support the wide overhanging roof. The entrance is in the chapel-like wing on the right-hand side; this has brick arches on ground floor and three narrow lancet windows above.

In 1940, the building housed an Oral School for the Blind. Later it was used as a nightclub, a youth employment centre and a canteen for municipal busmen before its present use.

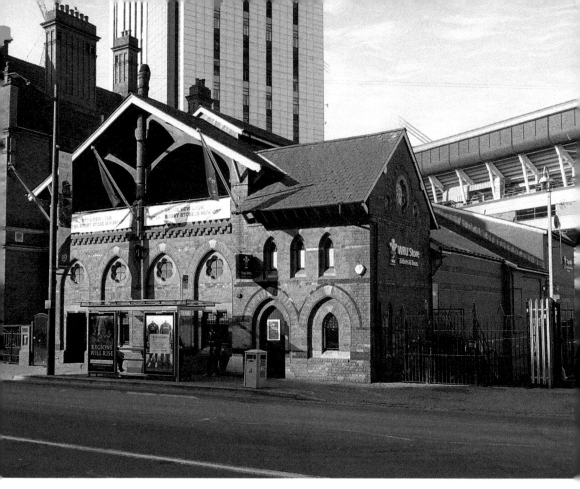

Jackson Hall.

9. Queen's Chambers, Queen Street

The Queen's Chambers Hotel was built in 1878 next to the tunnel by which the Glamorganshire Canal (1794) crossed under Queen Street. It was this relationship to the canal that no doubt inspired the architect, Charles E. Bernard, to design the hotel's exotic front in Venetian-Gothic style with a projecting first-floor oriel. Presumably aware of John Ruskin's *Stones of Venice*, the ornate windows appear to have been based on those of the Ducal Palace or the Casa d'Ora in Venice.

A few years later, the passage leading to the rear of the Queen's Chambers Hotel was used as the entrance to the Queen Street Arcade, which was designed by Edwin Seward and built in 1886. In 1992–94 the arcade was reconstructed and its entrance moved eastwards to connect with the first phase of St David's Arcade. At the same time the Venetian-Gothic front to the Queen's Chambers was restored to its original appearance (except for the ground-floor windows, which were originally built with pointed heads).

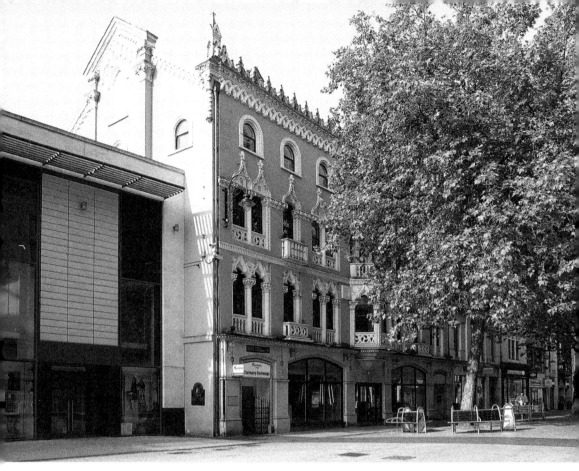

Queen's Chambers.

1c. Yr Hen Llyfrgell (The Old Library), Trinity Street

Cardiff's Free Library and Museum was founded in 1862 as the first library to be established by a local authority in Wales under the 1855 Public Libraries Act. Despite an optimistic beginning, the library was housed in various temporary locations before finding a permanent home for itself on an island site next to St John's graveyard. An architectural competition was held in 1880, which was won by Edwin Seward for a design in Bath stone in a rather heavy-handed classical style. The first part was opened in June 1882 with accommodation for the library only. It was extended southwards in 1896 and opened by the Prince of Wales, but still without provision for an intended museum. The principal (first) floor is emphasised by a row of Doric columns on the south front and by projecting bays to the side. At roof level there is continuous deep frieze extended upwards on the south front with a heavy parapet decorated with recessed panels containing figures and a large bust of Minerva.

The tiled passage alongside the rear entrance is lavishly decorated with encaustic tiles with geometric patterns to the floor and majolica tiles with floral designs to

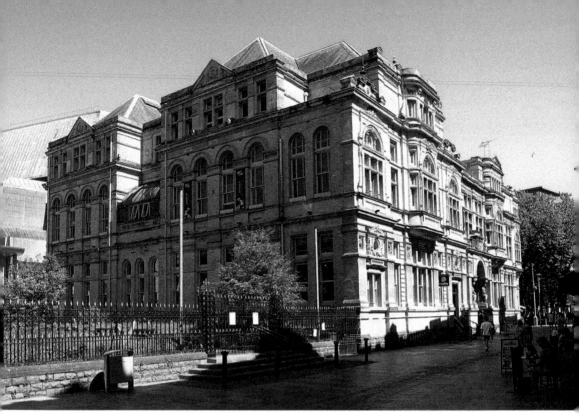

Yr Hen Llyfrgell (The Old Library), from the north.

the walls and overhead arches. They were made by Maw & Co. of Ironbridge, Shropshire, for what was originally known as the Museum Corridor, which led to the old museum.

The library closed in 1988 to become a craft and exhibition centre. In 2010, the main part of the ground floor and the basement were opened as the Cardiff Story Museum. Later, the remainder of the building became the home of a Welsh culture centre, hence the building's Welsh name.

11. St David's Roman Catholic Cathedral, Charles Street

The early growth of Roman Catholicism in Cardiff is mainly associated with the influx of people from Ireland, following the Potato Famine there in the first half of the nineteenth century. St David's Church in David Street was Cardiff's first Roman Catholic church when it opened in 1842. Designed by Joseph Scoles, it was a simple building in Romanesque style with four tall round-headed windows on each side. It was replaced by the present St David's Church in Charles Street in 1887 and was then used as a church hall until demolished in the 1970s.

St David's, on Charles Street, was built in 1884–97 to the designs of Edward and Peter Pugin, sons of Augustus Welby Pugin, a leading Catholic architect who argued in his writings that classical architecture was pagan and that Christian

churches should only be designed in the Gothic style, with pointed windows. It became the cathedral of the Roman Catholic Diocese of Cardiff in 1916. Tall and dark with rock-faced walls and red sandstone trimmings, it is somewhat undistinguished externally except by its full-height buttresses and a corner tower with a stumpy spire.

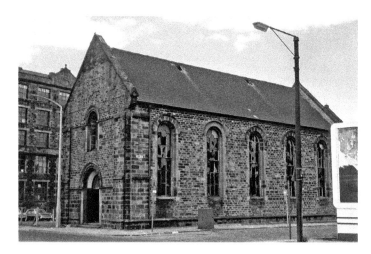

Right: St David's Roman Catholic Church, 1970.

Below: St David's Roman Catholic Cathedral.

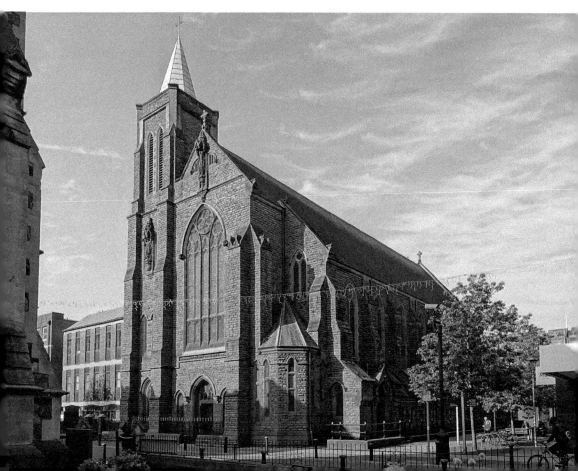

As at Llandaf Cathedral (*see* No. 38), the building suffered considerable damage from bombing during the Second World War and was largely gutted in 1941. St David's Cathedral was carefully restored by F. R. Bates, Son & Price, who introduced spindly hammer-beam roof trusses to the nave. The interior is entered under a deep gallery, supported on round modelled piers and segmental arches. There are no aisles, but there are side chapels, entered under pointed arches, and confessionals. The chapels have circular windows. The main features of the cathedral are a five-light window with geometrical tracery behind the gallery, and a circular window with hexagonal tracery (added in the 1950s) above the diamond-patterned reredos.

12. Market Hall, St Mary Street

Until the early nineteenth century the only place for a covered market was the partly open area beneath the Town Hall that stood in the middle of St Mary Street. At that time there were two markets: one for poultry, cheese and butter, and the other for corn. As the town began to flourish and rapidly grow in population, the need for a properly built covered market became obvious. At first this was provided for by a privately owned market in High Street, but when this closed the corporation decided to build a market hall on the present site in St Mary Street, next to the old police station.

The New Market, as it was known, opened in December 1835. Designed by Edward Haycock, it had a stylish entrance between tall square columns of stone, capped by a classical pediment. Behind it was a narrow section with fish stalls leading to a large shed-like market hall. Unfortunately, the new market was badly ventilated and gave rise to complaints of 'villainous smells'. Various proposals were put forward for a new market hall, but none were accepted. Eventually Solomon Andrews, a local businessman, bought the property and the police station next door and built the Market Buildings – a four-storey block with a central tower containing a camera obscura on the St Mary Street frontage with the market behind. It was opened to great acclaim in June 1884, but a year later the Market Buildings were destroyed in a great fire. The Market Buildings were rebuilt a year later, this time to a design by J. P. Jones with an extra floor, and opened in 1886. Above the two-storey central archway there is a curious two-storey curved oriel with closely positioned Corinthian columns.

Four years later the market itself was demolished and the present Central Market designed by the borough engineer, William Harpur, was built on the site behind the Market Buildings. Slightly longer than the earlier market, but otherwise covering the same piece of land, the main entrance is through the central archway of the Market Buildings in St Mary Street. The rear entrance in Trinity Street is in complete contrast to the St Mary Street frontage, with yellow brick walls, Tuscan pilasters and pediments in stone, and a date stone marking the opening in May

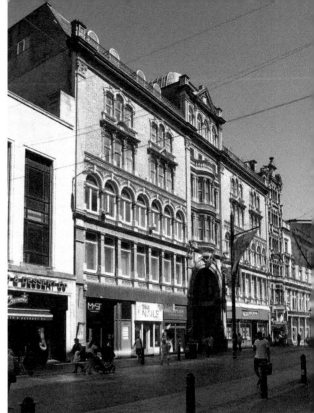

Right: Market Buildings and entrance to the market.

Below: Interior of the Market Hall.

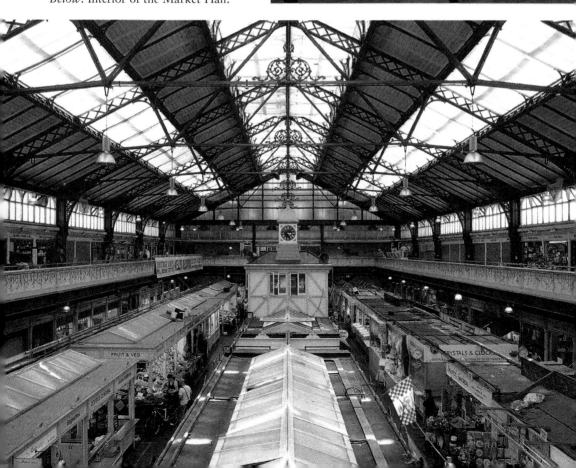

1891. Inside, the main features, apart from the stalls, are the sparingly decorated iron trusses supporting the wide semiglazed roof, the glazed end wall and a central clock tower marking the position of the market inspectors' office. Stairs at either end lead up to an encircling gallery for stalls specialising in non-perishable goods.

13. New Theatre, Park Place

Robert Redford, manager of the Theatre Royal in Wood Street, commissioned the architects Runtz and Ford to design the New Theatre in 1904. The foundation stone was laid in March 1906, and the theatre opened nine months later with a performance of Shakespeare's play, *Twelfth Night*. The theatre's main feature externally is the three-storey curved entrance pavilion in Arts and Crafts baroque, with the ground floor in Bath stone, the middle floor in red brick and the upper floor designed as a colonnade of Ionic columns between octagonal turrets (used for ventilation) surmounted by curved cupolas. Inside, there is a circular foyer with an oval staircase and an auditorium dominated by Ionic columns. When the theatre opened, the 76-foot-wide stage was said to be one of the largest in Britain. The theatre was bought by the council in 1969 and extensively restored in 1987–88.

New Theatre.

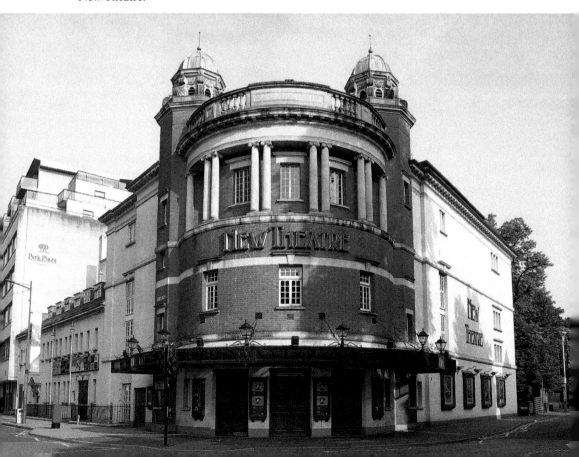

During its life the New Theatre has seen many great actors perform on its stage, including Sarah Bernhardt (1907), Anna Pavlova (1912), Jelly Roll Morton (1923), Vera Lynn and Tommy Handly during the Second World War, and famous locals such as Tom Jones, Tommy Cooper, Tessie O'Shea and Shirley Bassie. From 1954 to 2005 the theatre was the home of Welsh National Opera.

14. Cardiff Central Station, Central Square

The Central station, the largest and busiest station in Wales, came about as a result of the establishment of the South Wales Railway in 1845. The line had been proposed in 1836 as a broad-gauge railway that would run across southern Wales from Chepstow in the east to Fishguard in the west, with the possibility of connections to London at one end and the Irish ferry at the other end. One of the problems facing the proposed railway was finding a suitable site for the station, as the land near the River Taff was marshy and prone to flooding. The contract had been awarded to Isambard Kingdom Brunel, whose solution was to divert the Taff westwards and reclaim the land on its eastern side to provide a safe site for the station and new housing. The wooden station was opened on 18 June 1850 when the first train ran from Cardiff to Swansea, the line being operated by the Great Western Railway (GWR) under a lease agreement.

The station was replaced in 1932–34 by a new one, designed by the Great Western's architect Percy Emerson Culverhouse. The outside of the long, handsome neo-Georgian front is clad in Portland stone with end pavilions divided into bays

Cardiff Central railway station.

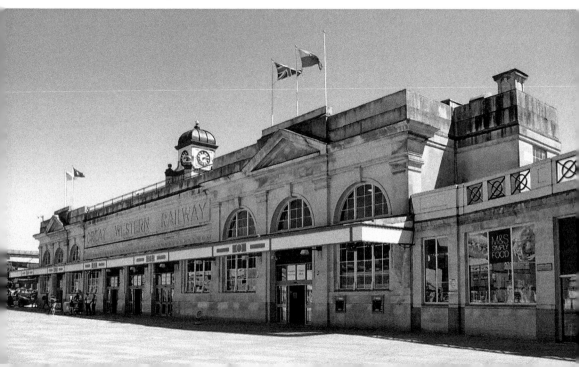

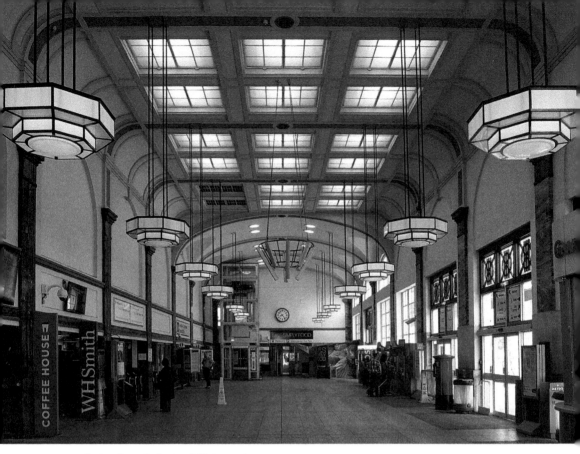

The booking hall, Cardiff Central station.

by Tuscan pilasters, large round-headed windows and pediments, while a five-bay central section incorporates three groups of doors beneath a later and continuous canopy. The words 'GREAT WESTERN RAILWAY' are prominently carved in the stone above the central section, with above this a stubby clock tower with a cupola. The grand interior comprises a generously proportioned booking hall divided into eleven bays by marbled Tuscan pilasters, with a panelled and partly glazed ceiling above supported by flattened arches in the centre and segmental arches at either end. Suspended from the ceilings is a splendid series of elegant art deco lights.

Beyond the booking hall, and reached by stairs, are a number of island platforms with canopies supported on Tuscan columns and single-storey blocks of waiting rooms faced in glazed tiles. A new entrance with reused fanlights from the earlier station has been added on the south side.

15. St David's Hall, The Hayes

Cardiff's premier concert hall is entered between a row of shops beneath what the *Building Design* magazine called the 'complex late brutalism' of exposed concrete balconies and structural frame in-filled with simulated Bath stone

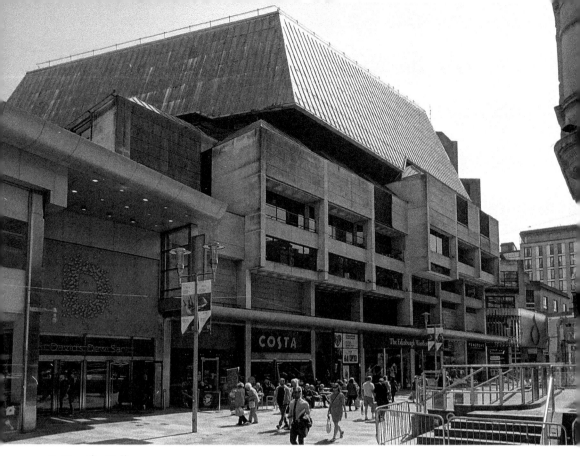

St David's Hall.

panels. Above this 'floats' a massive, zinc-covered roof. Unusually for a city of Cardiff's size, there had never been a dedicated concert hall (apart from a studio concert hall at the BBC in Llandaf) until the opening of St David's Hall in the autumn of 1982. Known as the National Concert Hall and Conference Centre of Wales, it was designed by the J. Seymour Harris Partnership, who had to confront the challenging task of integrating the building into the partly completed St David's Shopping Centre. Consequently, it took five years from instigation to completion. The crude external metal railings and insensitively positioned giant TV screen at an upper level are recent additions.

The entrance foyer is at street level, but the 2,000-seat auditorium itself was built two floors above the shops. Conceived as an 'in the round' layout to give it a theatrical feeling, the auditorium was designed to a polygonal plan, around which are a series of interlocking tiers providing excellent sight lines for the audience in every part of the hall. It has an 'acoustically transparent' ceiling, which gives it a somewhat fussy look. In addition to the auditorium and dressing rooms there are three more spacious and interlinked foyers, a couple of lounge bars and a restaurant. On one of the foyers there is a large hand-painted stained-glass mural.

In addition to musical concerts and conferences of all kinds, St David's Hall holds regular art exhibitions. It is also home to the annual Welsh Proms and the bi-annual 'BBC Cardiff Singer of the World' competition that was the launching pad for Bryn Terfel, the world-famous baritone, in 1989.

16. Principality Stadium, Westgate Street

The huge, bowl-shaped stadium was built to replace the old National Stadium on the same Cardiff Arms Park site between Westgate Street the River Taff. Because of its size and height, it is one of Cardiff's most outstanding and recognisable structures. Originally known as the Millennium Stadium, in recognition of the £46 million of public funds provided by the Millennium Commission towards the total cost of £121 million, it was renamed the Principality Stadium in 2016 as part of a sponsorship deal.

The history of the site as a sports venue goes back to 1848 when the Cardiff Cricket Club was established at the Cardiff Arms Park, Westgate Street. This was followed by the Cardiff Rugby Club in 1876 on an adjoining site.

Principality Stadium.

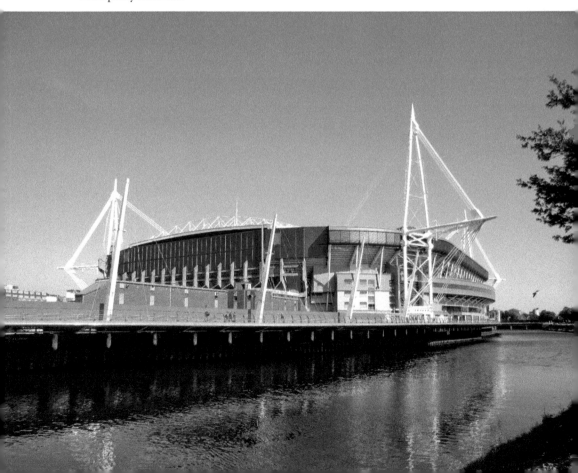

A 40,000-capacity stadium was built in 1904 by the Cardiff Rugby Football Club in association with the Welsh Rugby Union. This was badly damaged during the Second World War and was later rebuilt. A new National Stadium was constructed for international matches and events in stages between 1970 and 1984, with Cardiff RFC moving to a smaller purpose-built stadium on the former cricket ground to the north. Although the National Stadium had been designed for a capacity of 65,000 (later reduced to 53,000) it proved to be too small, and ten years later it was decided to build a larger stadium. This, the Principality Stadium (or Millennium Stadium, as it was then known), opened in June 1999 in time to host the 1999 World Rugby Cup.

The stadium was designed by Bligh Lobb Sports Architecture, with W. S. Atkins as engineers, for a seating capacity of 74,500 and a fully retractable roof. There are three tiers of seating on three sides, but the north side, which incorporates part of the old National Stadium's concrete North Stand, has only two tiers of seats. Externally, one of the main features are the 296-foot-high pylons that support the roof with its enormous sliding section at the four corners. In order to build the stadium a number of nearby buildings had to be demolished and the site widened by constructing a River Walk partly above the Taff. The stadium has seven entrance gates. Close to the Westgate Street entrance there is a 9-foot-high bronze statue (sculpted by Roger Andrews) of Sir Tasker Watkins, a former president of the Welsh Rugby Union.

Cardiff Arms Park Stadium, 1980.

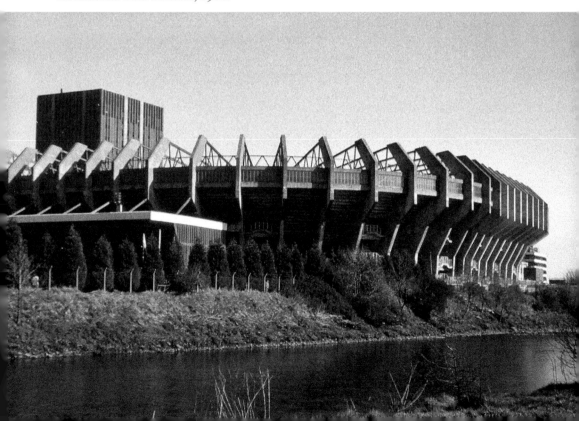

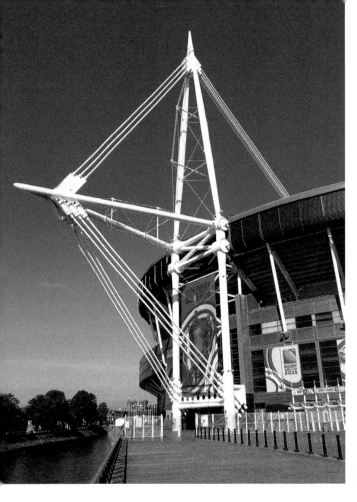

A corner pylon at the Principality Stadium.

17. Central Library, The Hayes

The shiny glass-faced library at the lower end of The Hayes is the fourth of Cardiff's main libraries, replacing the Old Library at the upper end of The Hayes (*see* No. 10), which closed in 1988. Thereafter, the Central library was housed in temporary buildings for twenty-one years. The new library was designed by the Building Design Partnership to a polygonal plan as a landmark building symbolising the values of knowledge, learning and culture. Construction began in 2007 and the building was opened in March 2009. Six floors high, the library has a full-height atrium, around which are book stacks on the first to fourth floors containing almost 2 miles of shelving. Designed as an energy-efficient building, it has a sedum grass roof to improve insulation, an outer skin of coloured glass panels, 'brass' cladding to the rear elevation, solar shading to prevent excessive heat and individual climate control to each floor. The ground floor is partly occupied by retail outlets and the sixth floor is sublet. The L'Alliance sculpture, with its rocket-like arrow within a steel circle in front of the library, was created by French sculptor Jean Bernard Metais and installed in 2010.

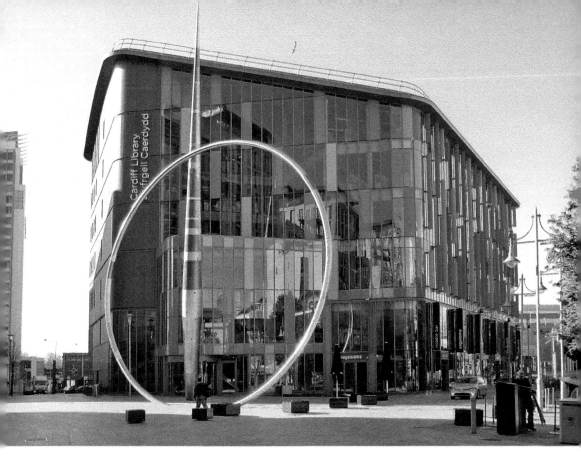

Central Library.

Cathays Park

18. Park House, Park Place

The bold three-storey house (now a club) was designed by William Burges for John McConnochie, Lord Bute's engineer for the docks and mayor of Cardiff in 1880–81. Though not as exuberant as Burges's restorations for Cardiff Castle and Castell Coch, its neo-Gothic style with French overtones and mixture of textured stonework and Bath stone dressings became the inspiration for many other houses in the Cardiff area, such as those at the lower end of Cathedral Road.

The asymmetric front is dominated by the three-bay loggia with an arcade of tall, pointed arches supported on columns of marble-like pink granite. To the right are two six-part windows with pointed heads, separated by a buttress. The first-floor windows – three of which are set back above the loggia – have multifoil roundels under heavy, pointed arches. The main entrance is hidden away at the side under a lean-to porch with arches and columns similar to the front loggia. Inside, a lobby leads into a lofty stair hall with a pompous timber staircase. The upper part of the stair hall is lit by a large three-light early Gothic-style window. The internal rooms are heavily beamed.

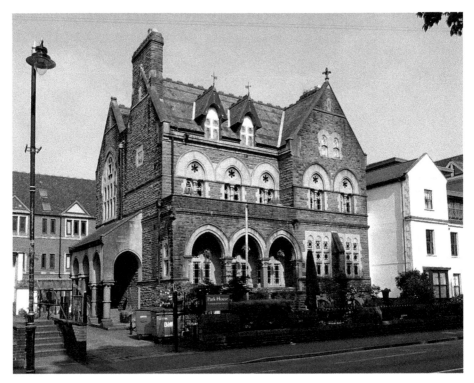

Park House.

19. Aberdare Hall, Corbett Road

The former University College of South Wales and Monmouthshire (now Cardiff University) had accepted male and female students on an equal footing from its inception in 1884. In reality this meant providing suitable accommodation for those women students away from home, both to avoid 'the hazards of life in mixed company' and also as a means of encouraging women to study for degrees. The first hall of residence for women students (and the second in Britain) was opened in October 1885 in Richmond Road, with an entry of nine students.

This soon became too small and in 1893 an acre of land in Corbett Road was leased from Lord Bute as a site to build Aberdare Hall as a new purpose-built hall of residence. Herbert Wills was appointed as architect and he designed the hall in Jacobean style with triple gables, projecting bays on either side of a central entrance, and mullioned windows. Built in red brick and red terracotta to a harmonious and dignified design, it stands out in both colour and detail against all the white Portland stone buildings in Cathays Park. The building was extended in 1905 to accommodate a further twenty students. Aberdare Hall was named after the 1st Lord Aberdare (Henry Austin Bruce), who was the first president of the University College and first chancellor of the University of Wales.

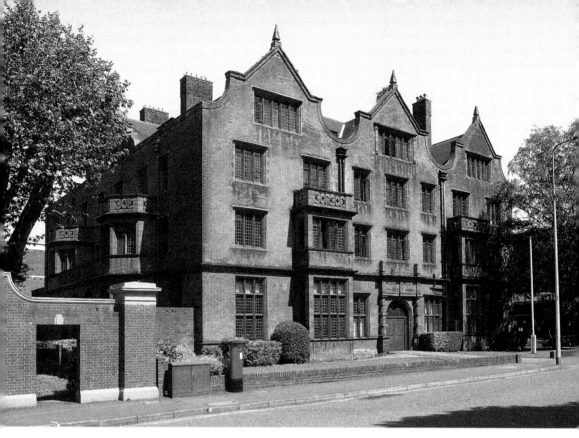

Aberdare Hall.

2c. City Hall, Gorsedd Gardens Road

After decades of argument in the nineteenth century about the need for a new town hall and other public buildings in Cardiff (and where to put them) and years of discussion with the Bute estate, the 3rd Marquess of Bute agreed to sell 60 acres of land in Cathays Park to the Corporation in 1898. Even before the agreement received parliamentary approval, however, the Corporation had held an architectural competition in 1897 for a new Town Hall and Law Courts on the site, stipulating a maximum of £125,000 to be spent on the Town Hall and £75,000 on the Law Courts. The competition was won by the London practice of Lanchester, Stewart & Rickards, out of fifty-six entries. Construction began in 1900 with completion in 1905, by which time Cardiff had reached a population of over 170,000 and had become a city and the Town Hall had become a City Hall.

The City Hall occupies a dominant position in the park, one admirably suited to show off its richly baroque design in Portland stone. The main two-storey south front has corner pavilions decorated with sculptural groups and an elaborate centre section with a protruding porte cochère and behind that a tall round-headed window. A lead-covered dome with a snarling dragon signifies the key position of the Council Chamber and its importance in the affairs of the

Above: Cathays Park with the Law Courts, City Hall and National Museum.

Below: City Hall.

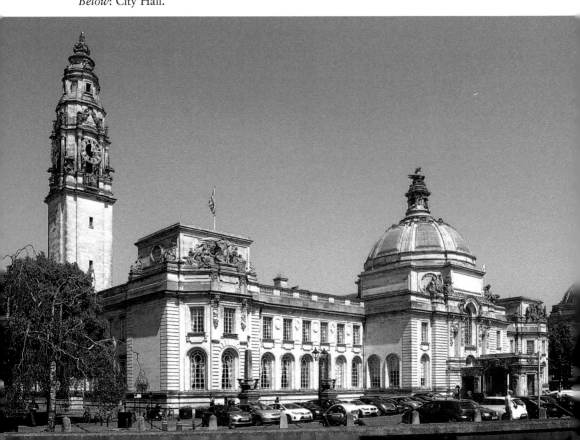

city. A prominent eye-catching 200-foot-high clock tower on the west front faces the Law Courts. The lower part of the tower is severely plain, before suddenly erupting into a series of columns, volutes and a sculpture representing the four winds, topped by a 'wedding cake' dome.

The interior of the City Hall is, if anything, even more sumptuous than the exterior. From the main entrance a short flight of steps leads into a spacious but rather austere hall faced in Bath stone, before giving access via two grand staircases – one on each side – to the main civic areas on the first floor. The first of these is the Marble Hall, an impressive space lined on both sides with pairs of Doric columns made from yellow Sienna marble. Here there is an important collection of eleven statues in Serrvezza marble commemorating Welsh heroes (and one heroine) from the past. At the southern end of the Marble Hall is the Council Chamber, with an unusual circular layout and a beautiful stained-glass window. Perhaps the most stunning thing is the coffered dome above chamber, from which hangs a splendid chandelier designed by E. A. Rickards. At the northern end, the Marble Hall opens into the large Assembly Hall; this has a tunnel-vault ceiling with decorative plasterwork and yet more great chandeliers by Rickards.

City Hall, the Marble Hall.

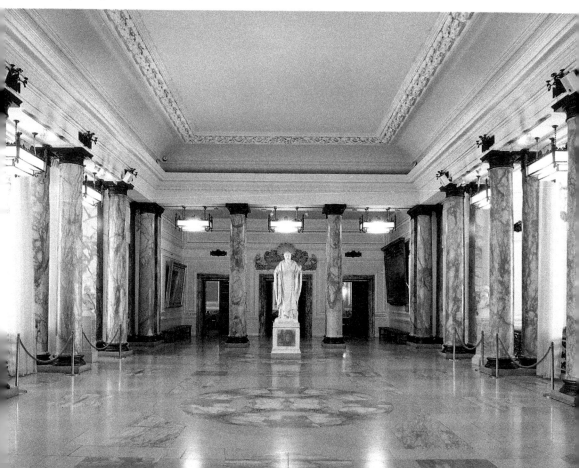

21. National Museum of Wales, Gorsedd Gardens Road

The growing cultural and patriotic movement that had been set alight in Wales during the 1880s by the Cymru Fydd ('Young Wales') crusade continued until the First World War. Out of this crusade had grown a desire for a national library and a national museum along the lines of those that had been erected in Ireland and Scotland. This resulted in a decision in 1905 by the Privy Council in London to award the National Library to Aberystwyth and the National Museum to Cardiff. Two years later a Charter of Incorporation brought the National Museum into theoretical being. An architectural competition for the new museum was held in 1909, the winners being the London firm of Smith & Brewer with a neoclassical design for a, quadrangular building around an elongated courtyard.

Construction began in 1911, but was soon brought to a standstill by the First World War. Work began again in 1918, and the first part of the building was opened in 1927. Subsequently, building work continued in separate phases until the museum reached its present form in 1992, but without the planned internal courtyard. As with the City Hall, the National Museum was designed as a two-storey building clad in white Portland stone, and featuring a large dome. The main front has a row of paired Doric columns in front of the entrance and pavilions on either side with Doric columns and sculptured groups at a high level.

National Museum of Wales.

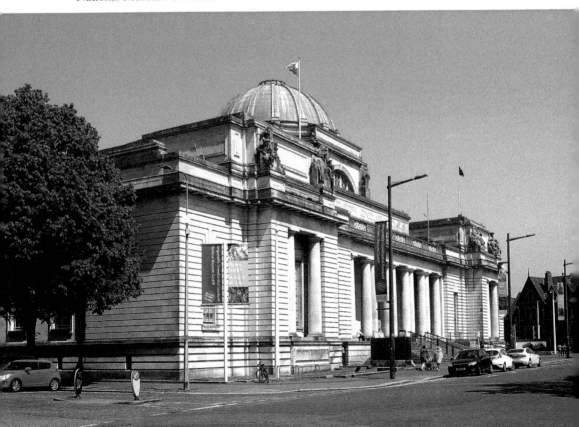

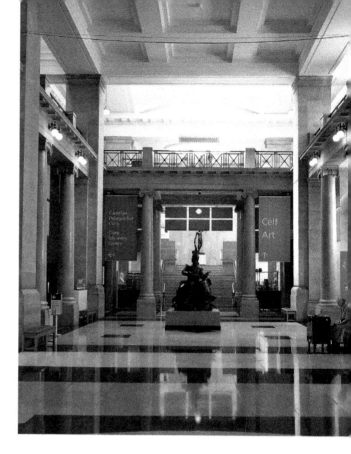

National Museum of Wales, the
entrance hall.

Inside, the dome-covered entrance hall forms a dramatic space with slightly
pinkish light flooding in from semicircular windows around the base of the dome.
The galleries lying at right angles to the ends of the entrance hall (two floors for
the east galleries and three floors for the west galleries) are mainly devoted to
wonderful collections of art and zoology while those in the centre (behind the
entrance hall) are mainly for earth sciences.

Originally, the museum housed galleries exhibiting archaeology, art, botany,
folk life, industry and zoology. Three of those departments were moved out over
the years to specialist branch museums in other parts of Wales, leaving only the
departments of Art, Geology and Natural History in the main building. The Art
Department has an outstanding selection of Impressionist and post-Impressionist
paintings based on the early twentieth-century collection by the Davies sisters of
Gregynog.

22. Cardiff University, Museum Avenue

The university began life as the University College of South Wales and
Monmouthshire in 1883 in the old Infirmary building in Newport Road. Later,
it was decided to move the college to a site in Cathays Park, and an architectural
competition was launched for the proposed new building. A quadrangular design

with a large courtyard by W. D. Caroe was chosen in 1903 as the winning entry, and construction began in 1905. From then on the building was completed in phases, with the first phase (for the administration and library) being opened in 1909 and the last phase (facing Park Place) in 1962.

Caroe's design was for an English Renaissance-style building, although he himself had been brought up within the tradition of Gothic Revival architecture. The result was to be a strange mixture of shapes and surface decoration that somehow still manages to hang together. The exceptionally long main front, facing Museum Avenue, has an eleven-bay centre section with three-storey castle-like 'towers' on either side of a two-storey neoclassical entrance façade, complete with Ionic columns and pediment. The rest of the two-storey main front continues with round-headed windows or rectangular windows within blind arches on the ground floor and tall, mullioned windows on the first floor, except for the end pavilions, which have pedimented windows on the first floor.

A large library on the first floor projects into the courtyard at the rear. It has a beautiful vaulted and coffered ceiling and is lit from a large Venetian window at one end. Caroe had originally envisaged a Great Hall on the far side of the courtyard facing Park Place, but this idea was abandoned after the Second World War when the University College began expanding into other parts of Cathays Park.

Cardiff University, from Museum Avenue.

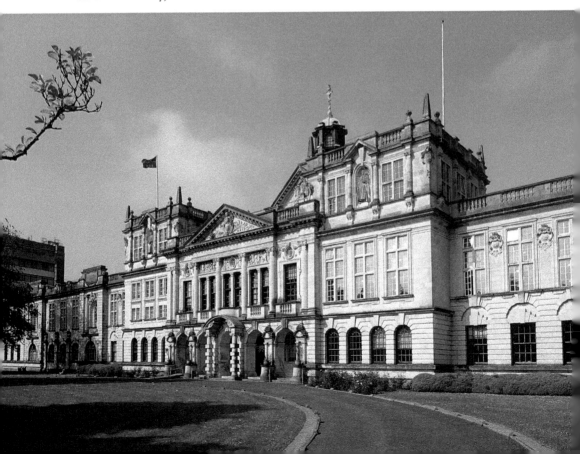

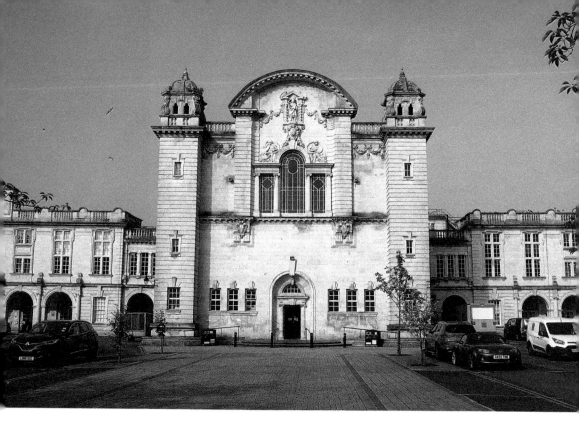

Cardiff University, from Park Place.

In 1988, the University College merged with the University of Wales Institute of Science and Technology (also in Cathays Park). The merged college and institute became independent of the University of Wales in 2004, finally becoming Cardiff University.

23. Glamorgan Building (former Glamorgan County Hall), King Edward VII Avenue

The Glamorgan Building (now part of Cardiff University) is aesthetically one of the finest buildings of its period. It was originally built to house the old Glamorgan County Council, which until the early years of the twentieth century had held its meetings alternately in Neath and Pontypridd. It was then decided to base the council in Cardiff, and an architectural competition was held in 1908 to find the most suitable design for the new county hall. The competition was won by the Vincent Harris (then aged thirty-two), along with his colleague Thomas Moodie. Construction began in 1909 and the completed building was opened in 1912.

The building is a remarkable tour de force of neoclassical architecture. The main façade is monumental in scale, with the central part set back behind a portico of coupled, giant and fluted Corinthian columns. The end pavilions have

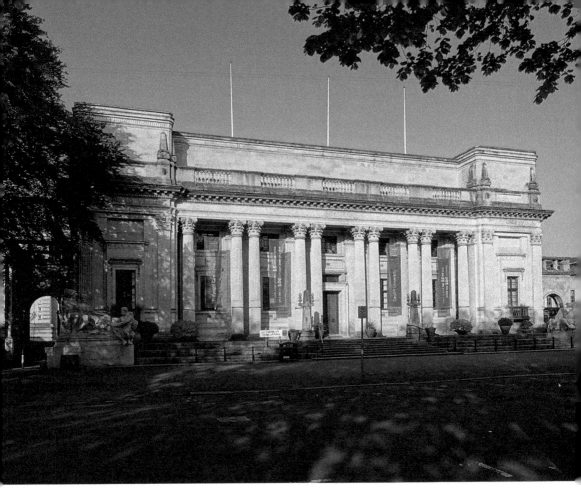

Glamorgan Building (former Glamorgan County Hall).

flat pilasters and the whole is surmounted by a continuous entablature above the columns and a bold cornice. Above this, set back behind a balustrade, is an attic storey. The approach to the main front is by way of steps, with bold sculptured groups (by Albert Hodge) symbolising Navigation (represented by Neptune) and Mining (represented by Minerva) at the sides. Inside, there is a fine D-shaped Council Chamber with an unusual hemispherical ceiling.

 The building was acquired by Cardiff University in 1997 to become the Cardiff School of Social Studies, after the county council's demise following the reordering of local authorities in Wales.

24. Welsh National War Memorial, Queen Alexandra Gardens

The elegant temple-like war memorial stands at the centre of the formally laid-out park in the middle of the civic centre. The proposal for a local war memorial had originated in 1917, and was later transmuted (despite some hostility from people in northern Wales) into a memorial that would be 'national'. Four architects were

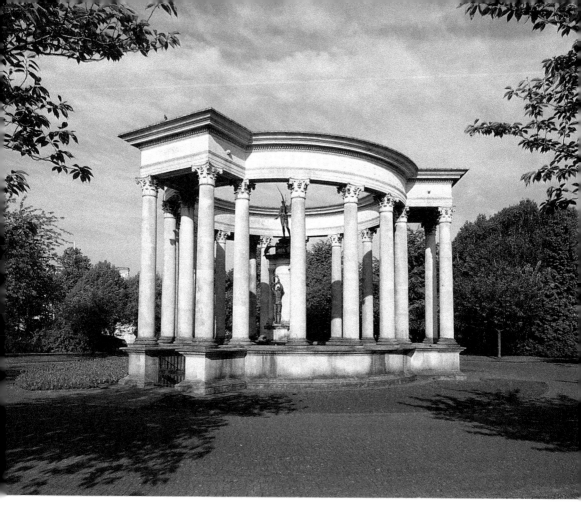

Welsh National War Memorial.

asked to submit designs for the memorial in 1922, and J. Ninian Comper's design for a circular colonnade (apparently based on one of Emperor Hadrian's buildings in Tunisia) was accepted. Construction began in 1926 and the memorial was unveiled by the then Prince of Wales in 1928.

The circular structure is supported on Corinthian columns and has three projecting porticos, allowing entrance into the inner, sunken part of the memorial. The inscription on the outer face of the frieze reads: 'I Feibion Cymru a roddes eu Bywyd dros ei Gwlad yn Rhyfel MCMXIV–MCMXVIII' (To the sons of Wales who gave their lives for their country in the war of 1914–1918). The inscription was later extended to include the fallen of the Second World War. Approximately 35,000 service men and women from Wales were killed during the First World War and around 15,000 during the Second World War.

The inner part of the memorial comprises a circular pillar ringed by three shorter Corinthian columns with, between the columns, bronze sculptures of a soldier, sailor and airman, and above those a splendid winged 'messenger of victory'. Below the pillar are three basin fountains with dolphins.

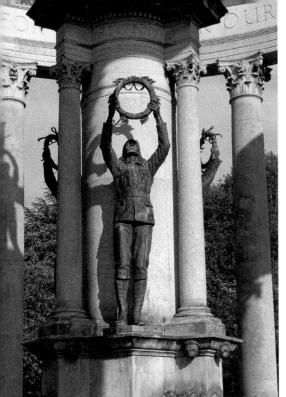 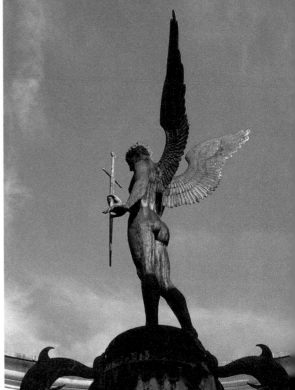

Above left: Welsh National War Memorial – internal column with statue of a serviceman.

Above right: Welsh National War Memorial, *Messenger of Victory* sculpture.

25. Temple of Peace and Health, King Edward VII Avenue

The building was the gift of Lord David Davies of Llandinam, a veteran of the First World War, to the Welsh nation in support of the causes of peace and health. It is in two parts: the Marble Hall, originally known as the Hall of Nations, and the administrative offices of two organisations dealing with international affairs and with public health. Designed by Percy Thomas in 1930 and amended in 1936, it was erected in 1938–39 with the help of £60,000 from Lord Davies towards the total cost of £72,000.

The building was opened on 23 November 1938 by Mrs Minnie James – one of the bereaved mothers of the First World War – ironically at the same time as workmen were constructing air-raid shelters on the adjoining land in preparation for the Second World War. Externally, the building has the stark simplicity reminiscent of 1930s Scandinavian neoclassical architecture, most notably in the projecting entrance portico with its square columns.

After the austerity of the exterior, the interior comes as something of a surprise. The entrance hall has walls of cream-coloured marble inlaid with gold rosettes and steps flanked by large black marble vases. The sumptuous Marble Hall at the rear has walls – broken by tall windows – lined with creamy-grey marble, a floor

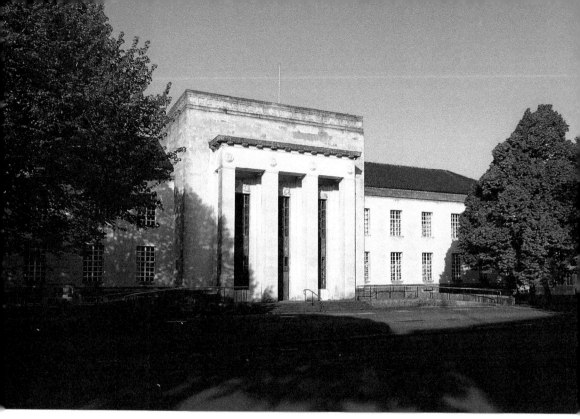

Temple of Peace and Health.

patterned in cream and orange travertine, square columns ribbed in black and gold marble and richly decorated ceiling with green and gold coffering. From the ceiling hang elegant art deco tubular-glass light fittings.

There is a small, vaulted crypt below, in which the Welsh Book of Remembrance is exhibited. The book bears the names of all the servicemen and women who lost their lives during the First World War.

26. Welsh Government Offices, College Road

Foundations for the first government building dealing with Welsh affairs, the Welsh Insurance Commission, were begun late in 1913 on a nearby site (now occupied by the Temple of Peace and Health). The start of the First World War soon brought work on the foundations to a sudden stop – work that was never resumed. Twenty years later plans were made for another government building, the Welsh Board of Health, on the present site overlooking Queen Alexandra Gardens. Construction work began in March 1935 and the long four-storey building designed by P. K. Hanton was opened three years later on St David's Day in 1938. Its strong repetitive pattern of elongated windows extending vertically across three floors was intended to give the illusion of a single high storey, topped by a bold cornice. Above the cornice, the setback floor with small square windows

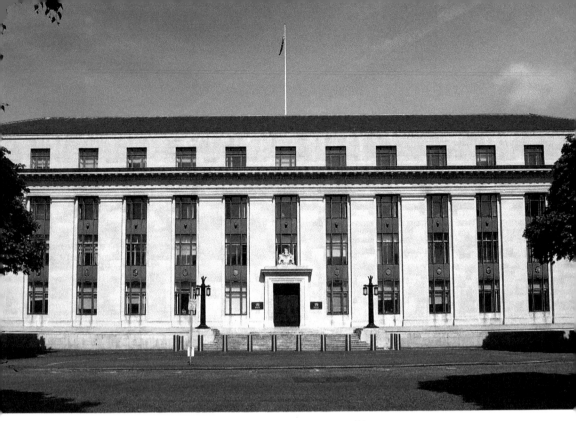

Welsh Government Offices (former Welsh Board of Health).

suggests a diminutive attic storey. Bronze window panels carry shields bearing the arms of the former counties and county boroughs, while above the entrance doorway there is a stone carving of the royal coat of arms.

The five-storey block of government offices at the rear, the former Welsh Board of Health, was built between 1976 and 1980 to the designs of Alex Gordon & Partners. An attempt was made to reduce the apparent bulk of the building by arranging the outer walls in different relative positions, with the lowest floors set back behind colonnades of rectangular columns as in a Grecian temple, and the uppermost floor set back and wrapped in bronze-coloured aluminium.

Both buildings became government offices of the Welsh Assembly after devolution had been granted to Wales in 1997.

27. Royal Welsh College of Music and Drama, North Road

The college was established in Cardiff Castle in 1949 as the Cardiff College of Music. It later became the Welsh College of Music and Drama and moved to a new home opposite Cathays Park, partly accommodated in a new purpose-made building and partly in the old Bute Mews. The new building facing North Road was designed by John Dryburgh, Cardiff's city architect, as a long four-storey range in light-coloured brick with a partly cantilevered top floor. It was opened in

1977 as the Raymond Edwards Building. In 2002, the college changed its name, becoming the Royal Welsh College of Music and Drama. The college merged with the University of Glamorgan in 2007 and when that merged with the University of Wales, Newport, became part of the University of South Wales Group.

Further expansion took place in 2011 with the addition of a dramatic new building that partly conceals the Raymond Edwards Building. The building was designed by BFLS Architects, and houses two performance venues: the 182-seat Richard Burton Theatre and the 400-seat Dora Stoutsker (concert) Hall. The spacious and lofty foyer looks directly on to Bute Park. From the outside the new building is full of curves with white fins to the southern half, a widespread overhanging roof and timber fins to the elliptically shaped concert hall.

The Bute Mews (formerly the stable block serving the castle) was included as part of the college when it moved from the castle. The building was designed by William Burges for the 3rd Marquess of Bute as a two-storey hollow quadrangle with a three-storey gateway on the south side and a two-storey gateway on the opposite side. The courtyard was surrounded by cloister-like lean-to roofs on timber supports. Half of the stable block was built in 1875, while the other half was completed in 1927 in a simplified version of the original. The Bute Mews was restored in 1999 and became the Anthony Hopkins Centre – named after one of the college's alumni.

Raymond Edwards Building, 1978.

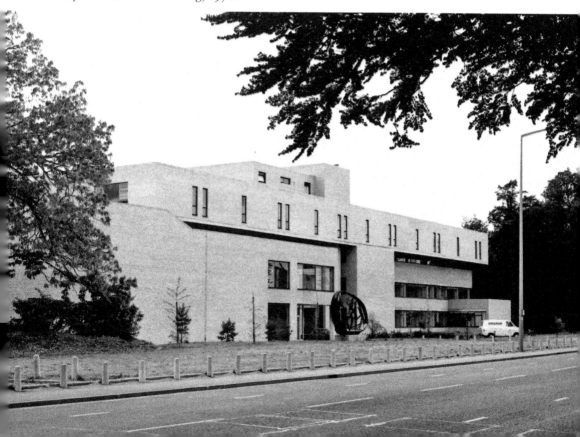

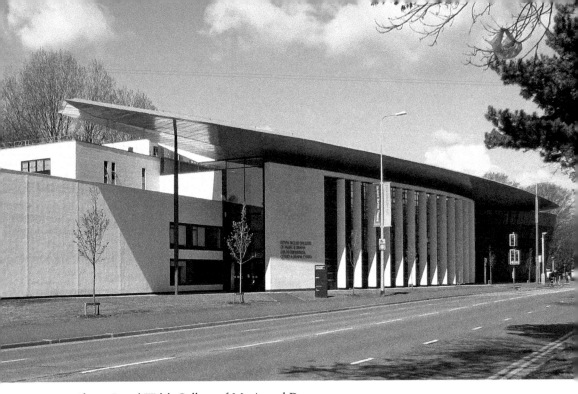

Above: Royal Welsh College of Music and Drama.

Below: Anthony Hopkins Centre (former Bute Mews), Royal Welsh College of Music and Drama.

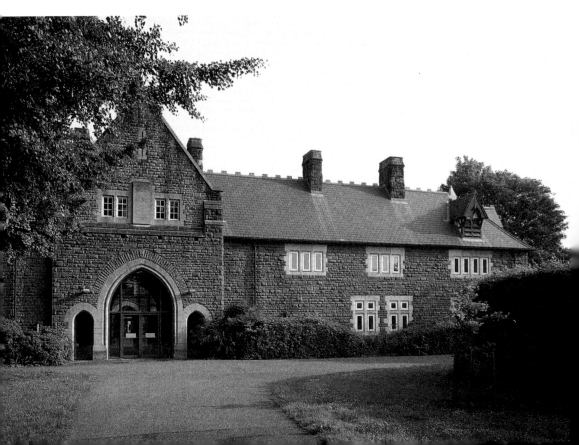

Butetown/Cardiff Bay

28. Bute Road Station, Bute Street

The white-rendered neoclassical building is one of the earliest examples of a purpose-built railway building in Britain. Constructed as the headquarters of the Taff Vale Railway (TVR), it formed, together with the single-platform Dock station on the opposite side of the track, the southern terminus of the railway that opened in October 1840. The TVR was largely sponsored by the iron masters of Merthyr Tydfil to overcome the inability of the Glamorganshire Canal to cope with an ever-growing amount of iron and coal traffic sent down the valley to the Cardiff docks for export.

The building appears to have been built in two sections: the northern three-storey part in around 1841–43, and the more elaborate two-storey southern section a few years later. It is not clear when the southern part was actually erected, but as the tall first-floor windows suggest sumptuous accommodation and the plan with its semi-hexagonal bay at the end resembles a drawing by Isambard Brunel, it seems likely that it was built to accommodate the TVR's boardroom sometime before Brunel died in 1859.

Former Bute Road station.

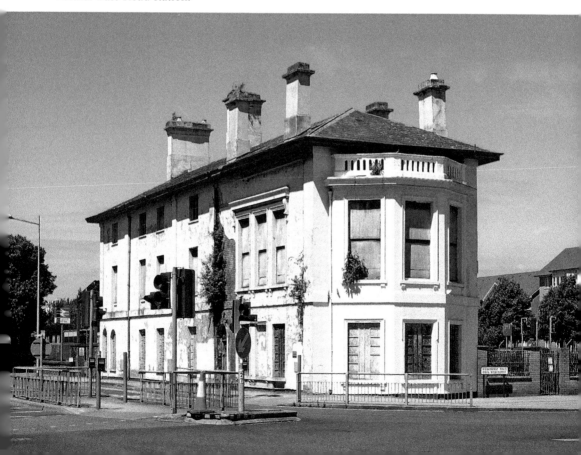

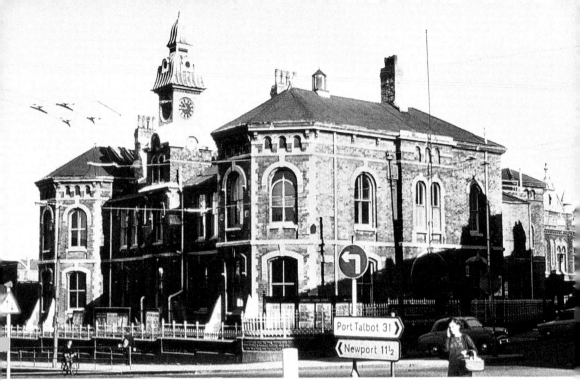

Taff Vale Railway Headquarters, Newport Road, 1966.

In 1862, the TVR's headquarters were moved to a palatial new building (opened 1860; demolished 1974) on Newport Road, close to Queen Street station. Following this, the northern part of the Bute Street building was leased out as consulate offices, while the southern part was used as the ticket office and waiting room for the Dock station. In around 1916 the Dock station closed and the Bute Street building was adapted as a railway station, known as the Bute Road station. During the 1970s and 1980s the building housed a railway gallery of the Welsh Industrial and Maritime Museum and the headquarters of the Butetown Historic Railway Society. The building is now derelict, awaiting possible conversion to flats.

29. St Mary's Church, Bute Street

In the seventeenth century the encroaching River Taff made the medieval church at the lower end of St Mary Street unusable, leaving the growing population in that part of the town without a parish church. A new St Mary's – designed by the Bristol architect Thomas Foster – was begun at the upper end of Bute Street 1841, and a year later William Wordsworth was induced to write a poem to help with fundraising for the church. Wordsworth's sonnet beseeched the builders to:

Let the new Church be worthy of its aim
That in its beauty Cardiff may rejoice.

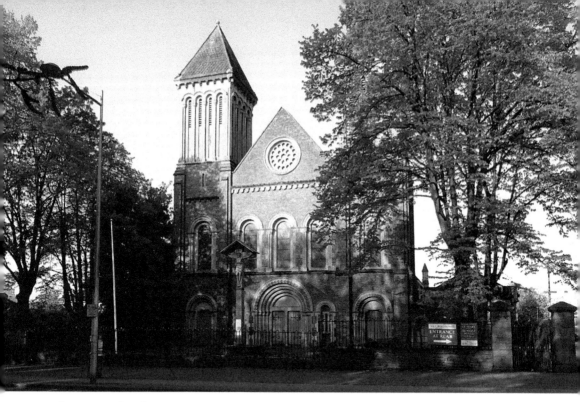

St Mary's Church.

Foster's church, a vigorous Romanesque-style building to seat 1,800 people, was one of the few churches built in the early nineteenth century with the aid of a parliamentary grant (together with money from the Marquess of Bute) that was neither Grecian or cheap Gothic. The church was consecrated in 1845.

The bold east façade has twin towers topped by stone pyramids and two ranges of round-headed windows and doorways, some of which are blind. The comparatively austere interior has a flat, plastered ceiling over the nave, open timber ceilings over the two aisles, stout columns supporting Byzantine-looking capitals, a gallery above the west entrance, and a semicircular apse complete with life-sized figures of the Apostles at the east end. Formerly, there were also aisle galleries and an enormous three-decker pulpit fronting the apse, but these were removed during the late nineteenth century. The mural paintings of St Margaret and St Winifred were added in 1891 and the fine wrought-iron screen from St Dyfrig's Church, Grangetown, was installed in 1969 when the latter church was demolished.

30. Former Bute Warehouse, Atlantic Wharf

A number of large nineteenth-century warehouses still remained at the northern end of the Bute East Dock in the 1980s. Most of them were built in massive masonry – up to eight storeys high – and are now gone. Fortunately, the finest warehouse, the brick-built Bute Bonded Warehouse, still survives at the head

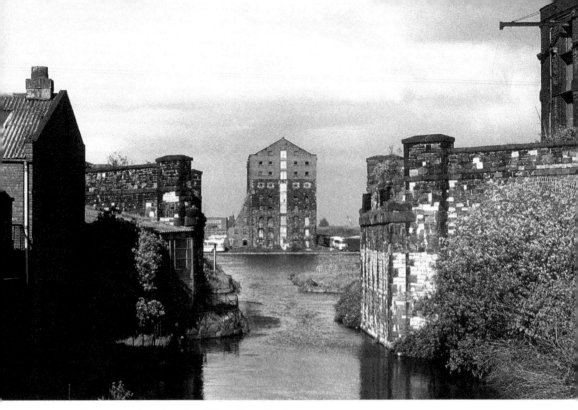

Above: Junction Canal and Bute East Dock, 1981.

Below: Bute East Dock and Bute Warehouse.

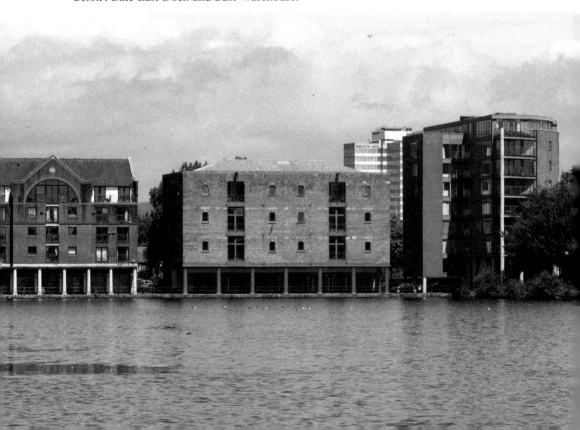

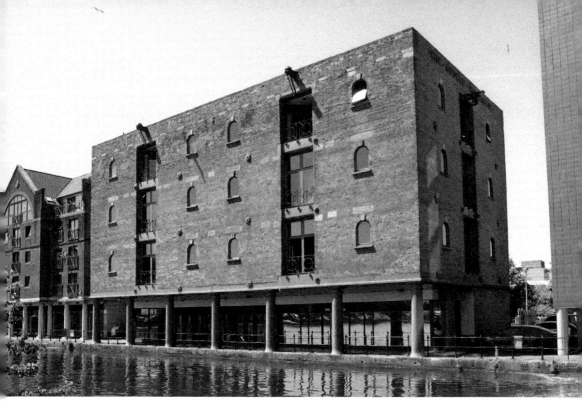

Bute Warehouse.

of the dock. It was designed by W. S. Clarke, the resident engineer, and built in 1861 in the functional tradition with a straightforward use of materials that gives it a feeling of strength, boldness and functional integrity.

Seen from the outside, the warehouse is a neat three-storey rectangular structure of solid red-brick walls – pierced by rows of small, round-headed windows and loading doors – above an open ground floor (through which a railway once ran). The warehouse's most interesting feature is its internal construction comprising an exposed iron framework of beams and round columns, six bays long by three bays wide. Each floor is carried on brick vaulting spanning between parallel beams. Stout, quasi-Doric, cast-iron columns form the outer row of supports on the ground floor.

The warehouse was converted to offices in 1987. During the conversion all the external metalwork was painted blue and a new entrance was added on the north side.

31. The Exchange Hotel (former Cardiff Exchange), Mount Stuart Square

Mount Stuart Square had originally been laid out as a park-like garden surrounded by high-status terrace houses, a few of which still survive. As the docks area thrived and the Port of Cardiff (which also included Barry and Penarth) became the largest coal-exporting port in the world, so the square became the commercial quarter of Cardiff with banks and offices occupying the original houses interspersed with new buildings. The erection of the three- and four-storey Exchange on the central gardens in 1884–86 completely altered the square's character.

Designed by James, Seward & Thomas in French Renaissance style, it had a boldly pompous main front on the south side, set back between projecting wings. The entrance, originally approached by curving stairs, has raised and paired Corinthian columns topped by a pediment and the royal coat of arms. The interior was remodeled in 1911–12 by Edwin Seward, giving the plain and undecorated trading hall – where the first ever £1,000,000 cheque was signed in 1907 – new life as a magnificent Coal and Shipping Hall. A rich and elaborate Jacobean-style showpiece in wood, it had two tiers of encircling balconies, Corinthian columns (some paired) and costly panelling. There were realistic carvings by Tom A. Jones of George V's bust gazing across to a pair of lions that supported clocks recording the tide times. A stained-glass window with ships is inscribed 'The Olde Order Changeth'.

The Exchange closed in 1958, and Cardiff's trade in coal came to an end a few years later. In the late 1970s, when devolution was first considered, The Exchange was earmarked as a possible home for a Welsh Assembly, and an underground car park was installed. Later it was considered as the headquarters for the Welsh televison station S4C, but that idea was also abandoned. Later still it became a venue for concerts, until safety concerns forced the building to close. In 2016/17 the building was converted into the Exchange Hotel, with a modern colonnaded rotunda in the forecourt. The former Coal and Shipping Hall has become a restaurant and the pair of sculpted lions have been moved to the entrance hall.

The Exchange Hotel (former Cardiff Exchange).

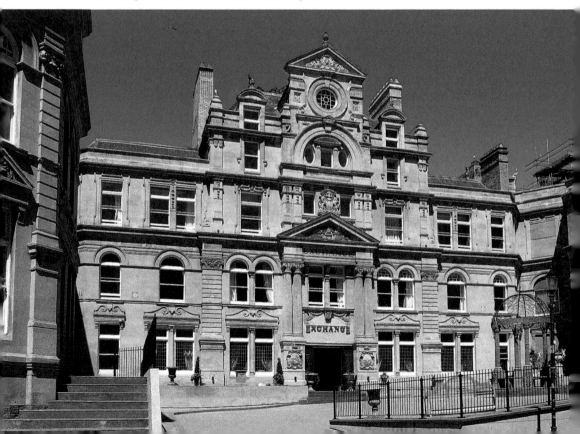

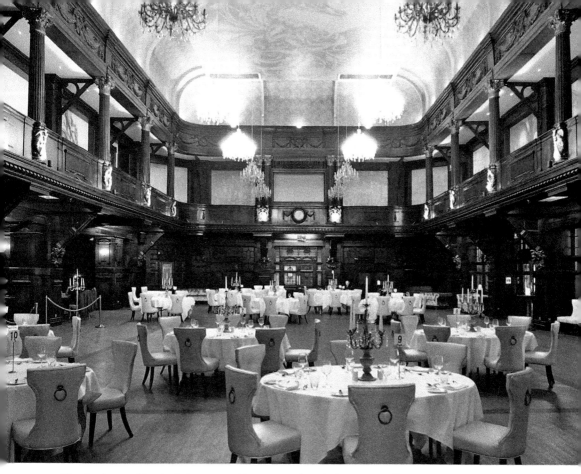

The Exchange Hotel, dining room (former Coal and Shipping Hall).

32. Norwegian Church, Harbour Drive

The church was originally erected near the southern end of the old Bute West Dock (since filled in) on land donated by the Marquess of Bute. Being so close to the dock, it was prefabricated in timber and clad in corrugated-iron sheets so that it could be moved if necessary. Consecrated in 1868, the Lutheran church came under the patronage of the Norwegian Seamen's Mission to serve the needs of sailors at a time when the Norwegian merchant fleet was the third largest in the world and Cardiff was one of the busiest ports in Britain. The bell tower and an internal gallery were added in 1885, while the reading room was enlarged and clad in wood in 1894.

The church also served the Norwegian community in the area, and among the worshippers was the Dahl family, whose son, the famous author Roald Dahl, was baptised in the building in 1916. During the Second World War the church became a home away from home for sailors unable to return to Norway while the country was occupied by Nazi Germany. When Cardiff's shipping trade declined after the war, the connection with Norway was loosened, so that in 1974 the church was deconsecrated and closed.

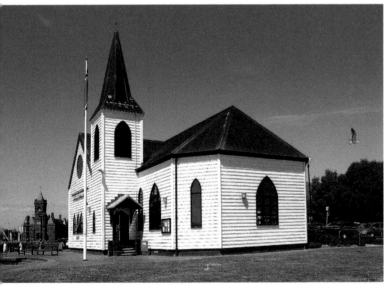

Above: Norwegian Church, 1970.

Left: Norwegian Church.

A Norwegian Church Preservation Trust was set up with the support of Roald Dahl, and together with a Norwegian Support Committee based in Bergen, money was raised to rescue the church in 1987 by dismantling and temporarily storing the structure. It was reconstructed in 1992 on its present site as the Norwegian Church Arts Centre. During reconstruction white-painted timber cladding was substituted for the original corrugated-iron sheets.

33. Pierhead Building

The Pierhead Building rises as a splendid red-brick and terracotta landmark, now isolated between the old entrances (both filled in) to the Bute East Dock and Bute West Dock. It was completed in 1897 as the headquarters of the Cardiff Railway, successor to the Bute Docks Co., to the design of William Frame, one-time assistant to William Burges, the restorer of both Cardiff Castle and Castell Coch. Like Burges, Frame was a lover of ancient castles, and it is not surprising that some of the Pierhead Building's detailing reveals the influence of Burges.

From the outside, the most striking feature of this ornate building is its fine skyline. This is produced by an exotic array of clustered hexagonal chimneys, pinnacled turrets and gargoyles, culminating in a fine castellated clock tower above the main entrance on the south front. Though French Renaissance style in detail, the overall effect has more of a Gothic flavour. The chimney piece on the west front is ornamented with a highly decorative panel with the arms of the borough and the Bute family sandwiched between a steamship and a steam locomotive with the motto below of '*Wrth Ddwr a Than*' ('By Water and Fire').

The interior is lavishly decorated for an office building. The entrance hall, with its brightly coloured wall tiles and a mosaic floor with the Bute coat of arms, leads into a grand church-like hall divided by three-bay arcades of round-headed arches (now obscured by subdivisions added in 1968). On the first floor the most ornate

Pierhead Building and Cardiff Bay.

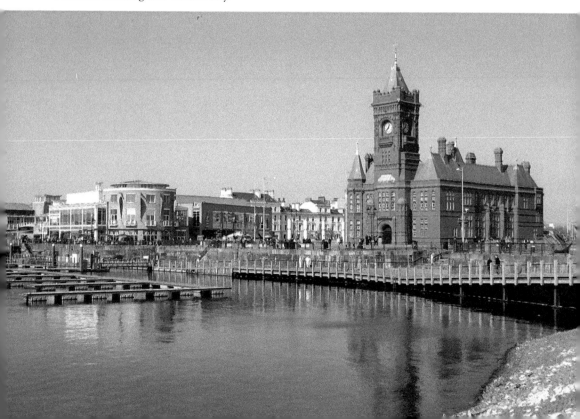

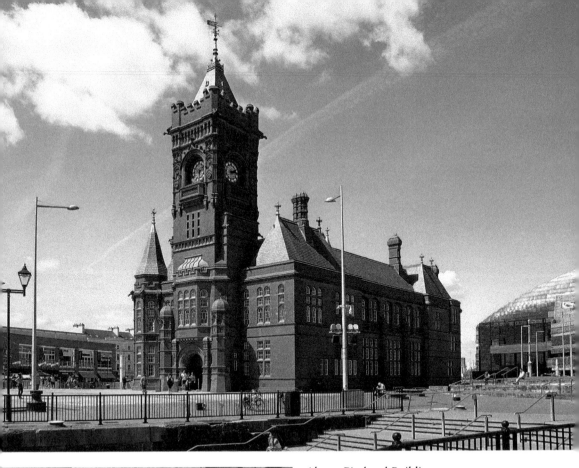

Above: Pierhead Building.

Left: Sculpted plaque on the Pierhead Building.

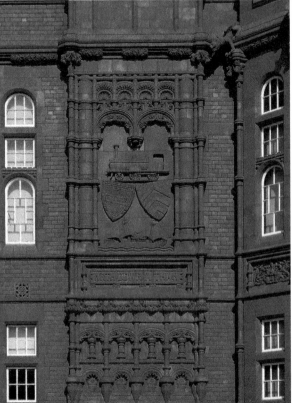

part is the manager's office, a fine room with a coffered ceiling, an elaborate a canopied chimney piece and a corner nook.

Following amalgamation of railway companies in 1921, the Pierhead Building became the headquarters of the Great Western Railway ports. Upon the nationalisation of the railways in 1948, it became headquarters of the South Wales Ports and later the administrative office of the Port of Cardiff. The building now houses the National Assembly's information centre.

34. Cardiff County Hall, Atlantic Wharf

With the decline in shipping after the Second World War, Cardiff's array of docks – once the heart of the world's largest coal-exporting port – gradually fell into disuse. The older docks closed (in 1964 and 1970), followed by the East Moors Steelworks in 1980 and much of the area became a site of post-industrial dereliction. The construction of the County Hall in 1986–87 to replace the City Hall in Cathays Park was the first determined attempt to regenerate the rundown docks area. Best seen across the water of the former East Bute Dock, it rises up in several tiers, pagoda-like, from the edge of the water, with each glass-fronted floor stepped back under shallow-pitched roofs.

It was designed by John Bethell, county architect of South Glamorgan (since disbanded), as a roughly square building of reddish brick, glass and black slate roofs around an open courtyard. Mostly three storeys, with the lower floors set slightly back between slender brick piers, it rises to four and five storeys in places where the roofs step back. The brick-clad interior is less impressive. The abstract metal sculpture, *Water, Coal and Steel*, set against a granite column, is by David Peterson.

Cardiff County Hall.

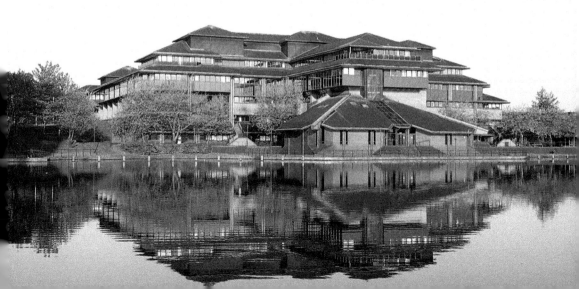

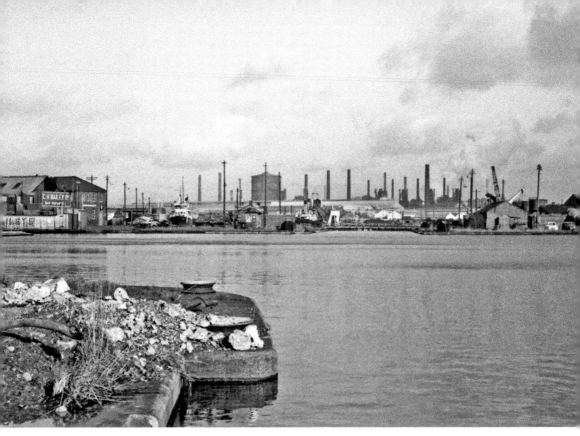

Bute East Dock, 1967.

35. Techniquest, Stuart Street

The national science and discovery centre was founded in 1986 by Professor John Beetlestone and colleagues of the former University College of Cardiff. It first opened in an old British Gas showroom in the city centre (St John Street). There is a sister building in Wrexham, and previously there were branches in Llanberis and in Narberth. In 1988, the Cardiff centre moved to a prefabricated building in Bute Street, and in 1995 to its current location in Stuart Street, on the site of a heavy engineering plant.

The present building – the first purpose-built science centre in Britain – was designed by Paul Koralek, of Ahrends, Burton and Koralek, who were able to reuse the iron framework of the original 1880s engineering workshop as the basis for the new building. As built, it is a fully glazed rectangular structure with a dramatic, curved single-span ceiling and roof. It looks out onto one of the graving docks of the old (*c.* 1860) Mountstuart Shipbuilding Yard.

Techniquest is an educational charity that offers visitors a hands-on approach to science and technology, and includes a science theatre, discovery centre and a planetarium. Exhibitions are taken around to events at many venues in Wales – from shopping centres to the National Eisteddfod.

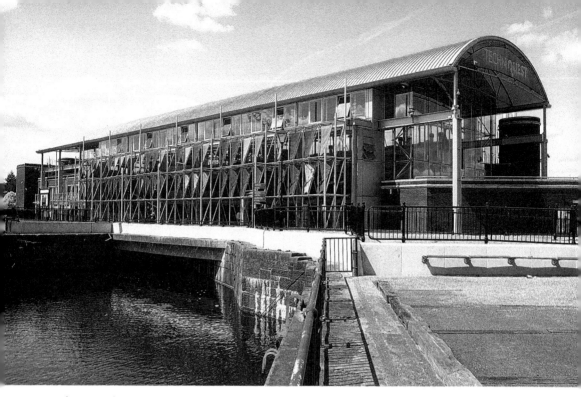

Above: Techniquest, from a graving dock.

Below: Techniquest interior.

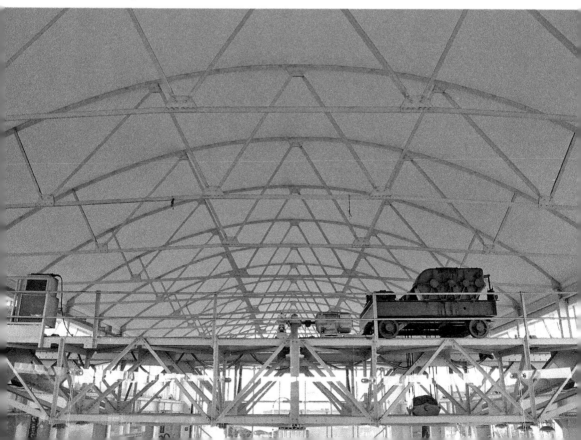

36. Wales Millennium Centre, Roald Dahl Plass

The largest by far, and the most striking, of the new buildings in the Bay area is the Wales Millennium Centre, which was designed by Jonathan Adams of the Percy Thomas Partnership and opened in 2004. Occupying a 3 hectare site, it dominates the east side of the Oval Basin, overshadowing its neighbouring buildings. Controversially, it replaced an earlier project for an opera house on the site that was won in competition in 1993 by Zaha Hadid and eventually dropped as being too elitist.

The centre, as built, is instantly recognisable by the enormous bronzed steel, bulbous shell covering the main auditorium, fly tower and foyers, and the long stratified wings of rock-cut multicoloured slate and glass on either side. There is a separate red-brick wing housing various arts groups, including the Welsh youth movement, Urdd Gobaith Cymru.

Externally, the curvaceous steel shell cantilevers out over the main entrance and has a steeply sloping face inscribed in giant letters – cut out of the metal – with the poet Gwyneth Lewis's interlinked lines: '*CREU GWIR FEL GWYDR O FFRWNAIS AWEN* – IN THESE STONES HORIZONS SING' (the Welsh translating as: 'Forging truth like glass from the furnace of inspiration). Inside there is a long, spacious concourse leading to cafés and retail outlets as well as stairs to the main performance spaces. Above the concourse are two levels of curving, hardwood-clad viewing galleries. The Donald Gordon Theatre, a 1,900-seat auditorium, is on an upper floor and is used for top-class shows, concerts and

Wales Millennium Centre.

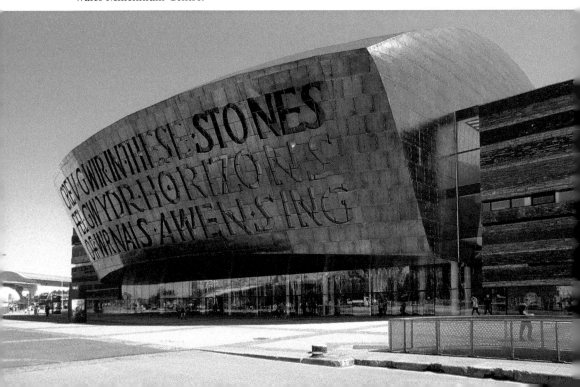

operas. It has two balconies and three levels of foyer bars. The wood-panelled Hoddinott Hall (opened in 2009, and also on an upper floor) is a concert hall seating 350 people and is used by the BBC National Orchestra of Wales for rehearsing and concerts. There is also the Weston Studio Theatre with 250 seats.

37. The Senedd, Harbour Drive

Dramatically sited close to the waterfront, the Senedd – home to the National Assembly for Wales – stands on a platform approached by a series of stepped terraces and ramps. The glass pavilion with a 'floating' roof that constitutes the Senedd suggests an ideal of openness and transparency in government. Designed by Richard Rogers Partnership, it was the winner of an architectural competition held in 1998, just a year after an affirmative vote in the devolution referendum, and opened in 2006. There was considerable debate about the Senedd's location, with a keen bid by Swansea to secure it and much talk of adapting Cardiff's City Hall, before a site was finally settled in Cardiff Bay.

The public entrance – originally intended to be on the main façade, but altered for security reasons – is through a single-storey extension at the side. The entrance leads into the foyer, a spacious area dominated by a magnificent undulating timber ceiling with its shallow domes. At the rear of the foyer, to the right of the reception desk, an opening leads directly to the public gallery where one can gaze down into the debating chamber, above which is a giant funnel that harnesses the outside

The Senedd and Cardiff Bay.

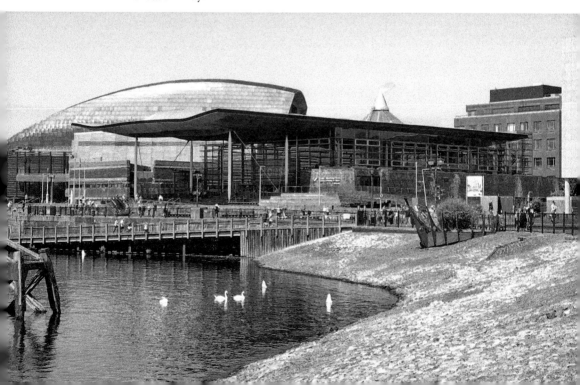

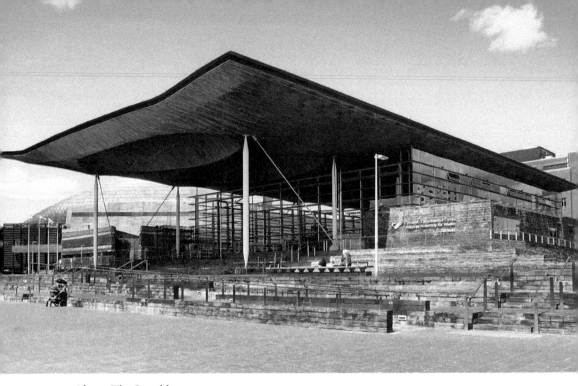

Above: The Senedd.

Below: The Senedd, looking towards upper foyer and the funnel over the debating chamber.

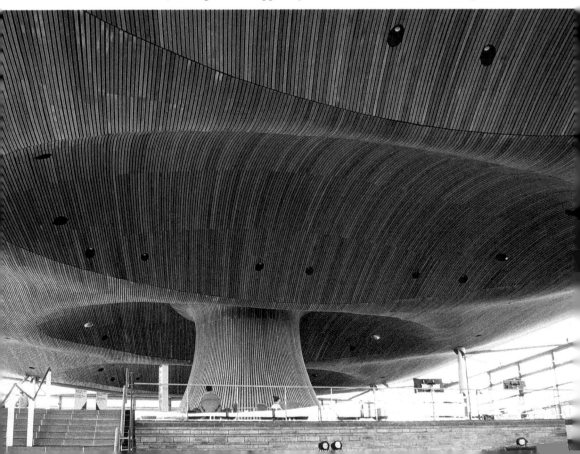

wind to ventilate the chamber. The debating chamber is circular, suggesting a sense of togetherness, rather than the Westminster type where parallel rows of seats face each other to favour a more adversarial form of debate.

From the foyer a slate staircase leads to an upper foyer where the main feature is the timber-clad funnel above the debating chamber. The upper foyer has a café and provides space for exhibitions. The committee rooms are, like the debating chamber itself, on a lower floor.

Llandaf

38. Cathedral

The Anglican cathedral is dedicated to five saints and is one the oldest continuously used church sites in Britain, with a history going back more than 1,400 years to the Celtic saints of the sixth century. The earliest timber monastery has disappeared without trace, as has the first stone church – a 40-foot-long apsidal-ended church built in the eleventh century. The sole reminder of this dark period is a late tenth- or early eleventh-century Celtic pillar cross with wheel head and knotwork panel, now in the south choir aisle.

The cathedral was rebuilt or restored five times, beginning with the first Norman cathedral. This was built around 1120–34 by Bishop Urban to a cruciform layout with an apse at the east end. Though much smaller than the present building,

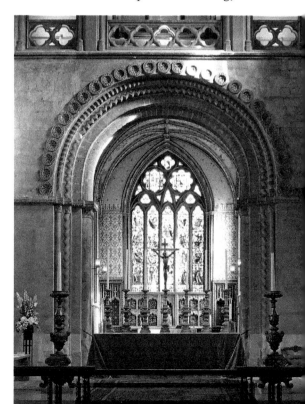

The presbytery arch, Llandaf Cathedral.

it must have been an impressive sight, as can be seen from the fine Romanesque arch between the Presbytery and Lady Chapel, which has three bands of decoration including an outer semicircle of medallions. Towards the end of the twelfth century, work appears to have begun on enlarging the cathedral in similar style, for which the main evidence now are the richly decorated Romanesque doorways to the north and south nave aisles.

During the early thirteenth century the nave and aisles were extended westwards. A square chapter house with pyramidal roof was also added on the south side, all in Gothic style with pointed-head windows. Towards the end of the century the five-bay Lady Chapel, with its delicate ribbed roof vaulting, was added at the south end. In the fourteenth century the aisle walls were largely rebuilt, now with larger three-light windows with reticulated tracery and ogee heads. The Perpendicular style north-west tower, or Jasper Tower, was added in the mid-fifteenth century. Its elaborate crown of openwork and pinnacles is a nineteenth-century replacement of an earlier crown.

By the eighteenth century the cathedral had become derelict and in 1722 the south-west tower collapsed. Rather than rebuild the whole church, a classical-style temple designed by John Wood of Bath was built in 1734 within the outer

The west front, Llandaf Cathedral.

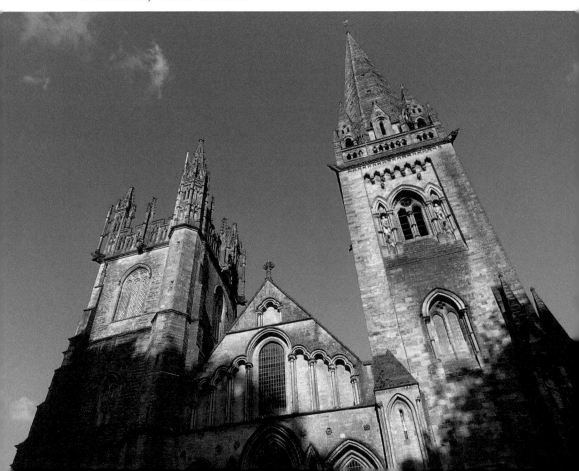

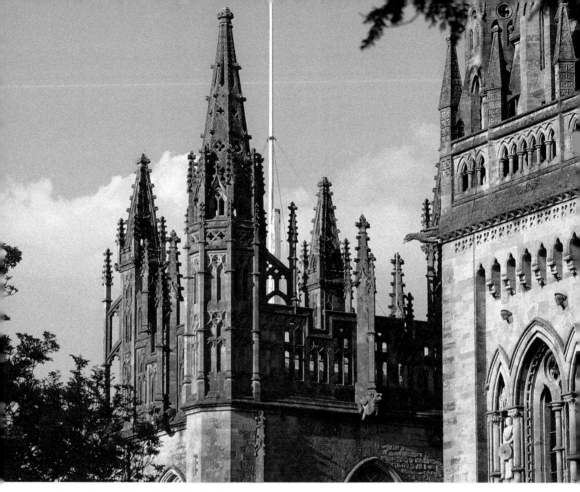

Japer Tower, Llandaf Cathedral.

walls, occupying the presbytery and four bays of the nave while leaving the rest of the church in ruins.

The classical temple was demolished in the next century and the cathedral was largely rebuilt in 1843–67 by local architect John Prichard. Among other things, Prichard was responsible for adding the splendid 195-foot-tall tower and spire at the south-west corner. Through the influence of Prichard's partner, John Seddon, many fine pre-Raphaelite works of art were added, including Rossetti's 'Seed of David' triptych now in St Illtud's Chapel beneath the Jasper Tower.

During the Second World War, the cathedral became a roofless ruin again after receiving a direct hit from an enemy mine. It was rebuilt and restored between 1949 and 1960 by George Pace, who installed a flat, panelled timber ceiling above the nave and installed a great parabolic concrete arch at the junction of the nave and choir. The arch carries a cylindrical organ case, adorned with an aluminium sculpture of 'Christ in Majesty' by Sir Jacob Epstein and pre-Raphaelite gilded figures. Pace was also responsible for the fine apsidal-ended David Chapel on the north side.

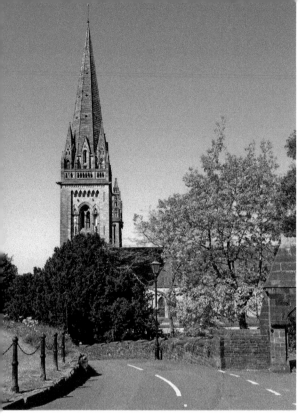

Left: South-east tower and spire, Llandaf Cathedral.

Below: The nave with arch and 'Christ in Majesty' statue, Llandaf Cathedral.

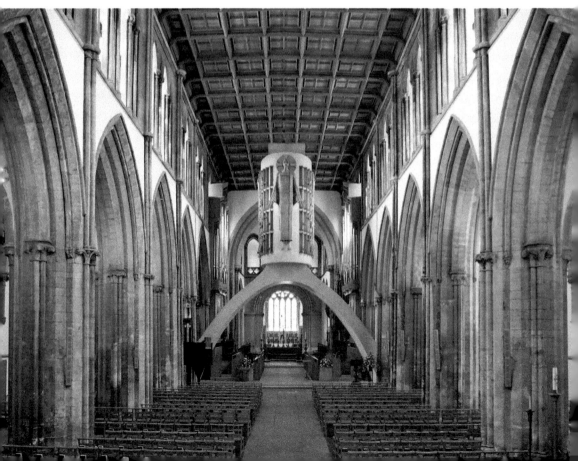

39. Bell Tower and City Cross, The Green

The craggy remains of the bell tower stand at the edge of the steep bank overlooking the cathedral. It was built during the thirteenth century to provide the diminutive cathedral with a place for bell-ringing that could be heard from a distance. It once held a bell known as 'Great Peter', which weighed 5.5 tons and was supposedly the largest in Britain. The tower, as originally built, appears to have been a comparatively low square structure with buttresses at each corner and an internal spiral stairs. Ruined since the fifteenth century, and obscured by later buildings, the tower was restored to view as a war memorial in 1924.

The thirteenth-century City Cross, standing in front of the bell tower, was, according to tradition, the place where Archbishop Baldwin preached in support of the Third Crusade on his journey around Wales in 1188. The archbishop was accompanied by Giraldus Cambrensis (Gerald of Wales) who recorded that, 'the English stood on one side and the Welsh on the other; and from each nation many took the Cross'. Only the shaft of the cross is original; the upper part was added in 1897.

The bell tower.

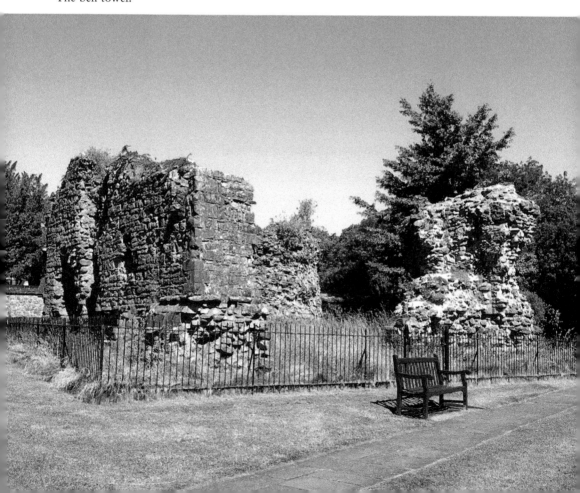

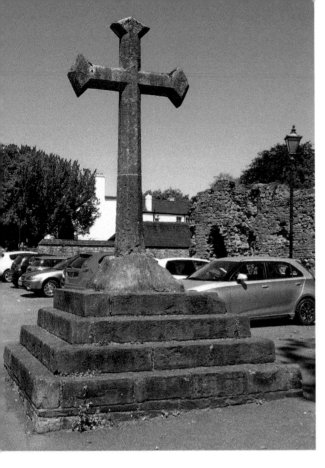

The City Cross.

40. Bishop's Castle, High Street

The castle seems to have been built between 1265 and 1287 by Bishop Braose, the English Lord of Llandaf, as a fortified palace during a period when attacks by former Welsh lords were still possible. It remained home to bishops of Llandaf until the early fifteenth century. After Owain Glyndwr's nationwide revolt (1400–10), the bishop moved to safer and more comfortable quarters at Mathern Place, near Chepstow.

The entrance to the castle is through the bold twin-towered gatehouse facing The Green. Originally three-storeys high with vaulted cellars, the towers are connected by a deeply recessed gateway with slots for a sliding portcullis. The gatehouse's design resembles work at Caerphilly Castle, suggesting that the castle might have been built in co-operation with Gilbert de Clare, the Anglo-Norman Lord of Cardiff, as part of a chain of castles that included Cardiff Castle and Castell Coch to protect de Clare's possessions and those of the see of Llandaf. There are few traces of any residential buildings inside the courtyard, apart from remains of two large windows in the north-east corner that indicate the former position of the Great Hall. There is a circular tower at the south-east corner of the courtyard and a square tower at the south-west corner. The castle was partially restored and the courtyard was laid out as a garden with herb borders in 1972.

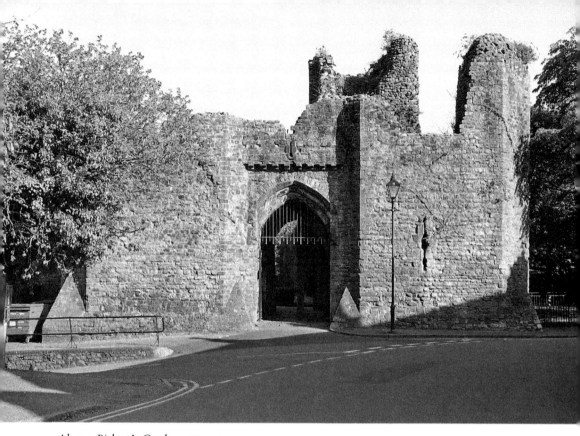

Above: Bishop's Castle – gateway.

Below: Bishop's Castle – courtyard.

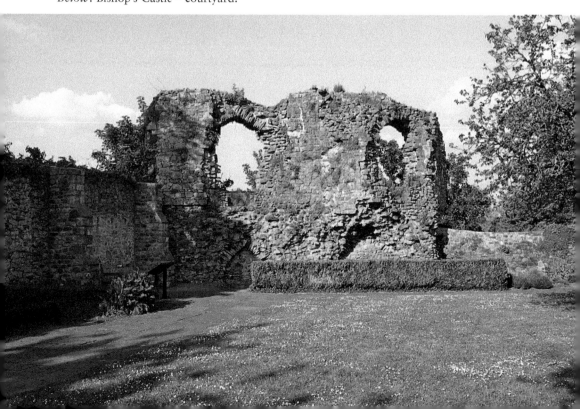

Llandaff Court, at the rear of the Bishop's Castle (drawing by David Hilling).

The rather plain Georgian house (Llandaff Court) at the rear of the castle was built in 1746 for Admiral Thomas Mathew. The house was acquired in 1869 by the see for use as an episcopal palace, marking the return of bishops to Llandaf. A neo-Gothic chapel designed by Ewan Christian was added at one end and the house was renamed Llys Esgob ('Bishop's Palace'). In 1958, the house became the home of the Cathedral School.

41. Insole Court, Fairwater Road

The house, originally known as Ely Court, was built in 1855–57 for James Insole, son of George Insole, founder of an important coal and shipping business. Designed by William G. Habershon, the original house was regularly added to: first by George Robinson (1873), who added a 70-foot-high castellated tower at the rear, and then by Edwin Seward (1877 and *c.* 1895), who added a Swiss-style north wing with half-timber cladding. One of the last additions seems to have been the early Renaissance-style porte cochère that fronts the Gothic entrance doorway. As seen from the lawn on the south side, the once modest-sized house had become a large multigabled mansion with numerous bay windows, subtlety linked at the upper level by openwork stone balustrading.

Inside, the spacious entrance hall has a ribbed and coved ceiling with central vault and a stone staircase with balustrades of marble-like alabaster from

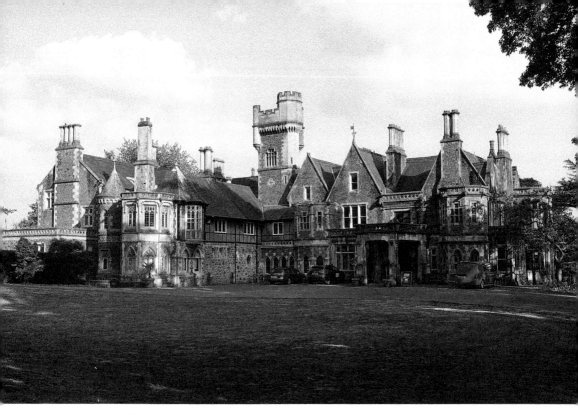

Above: Insole Court, the entrance front.

Below: Insole Court, the garden front.

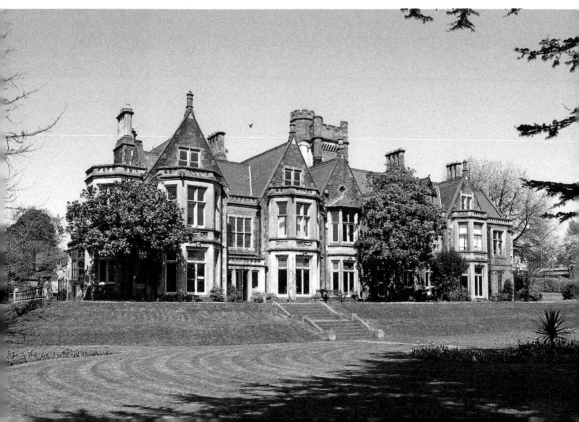

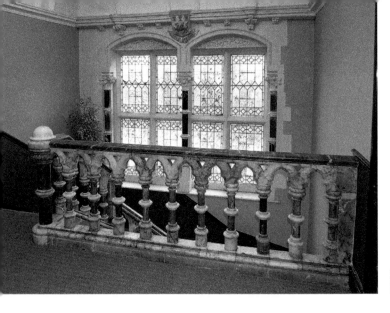

Insole Court, staircase balustrade.

Penarth – all lit from a large four-light window with decorative glass. The interior has ornately carved doors, carved alabaster arches to two of the window openings and is richly decorated, with much of it seemingly inspired by Burges's work at Cardiff Castle. The winter smoking room has a ribbed and coved timber ceiling with a painted frieze depicting the four seasons by Fred Weeks, while the library upstairs has a vaulted ceiling and walls with painted borders and scrolls. The house is now managed by a charitable trust and while the ground floor is open to the public, conservation work continues upstairs.

The grounds to the south and west of the house form a public park with terraced lawns, rock gardens, ornamental trees and shrubs and fine collections of Alpine and rock plants. There is also a rustic-looking six-sided summerhouse or gazebo.

42. St Michael's Theological College, Cardiff Road

The building started off as a two-storey red-sandstone house designed by John Prichard (architect of the cathedral and many churches and schools in the diocese) for his own use, but apparently never completed. It had pointed windows, balconies and a corner oriel that can be seen from the courtyard at the rear. A three-storey L-shaped building on plan containing a refectory and library was added by F. R. Kempson in 1905–07 when the house was converted to a theological training college. Independent blocks containing study bedrooms were added to the east, south and west sides of the courtyard in around 1915. Those on the west and south sides were demolished by enemy action during the Second World War, but have since been replaced by a long three-storey block on the west, linked to Kempson's earlier building by a two-storey link containing lecture rooms.

The college chapel, designed by George Pace, was erected in 1959 on the south side of the courtyard, taking the place of one of the lost student blocks. Built with blue-grey Pennant sandstone, it has a simple but sturdy character. The asymmetric gable are slightly curved and long walls contain batteries of small randomly

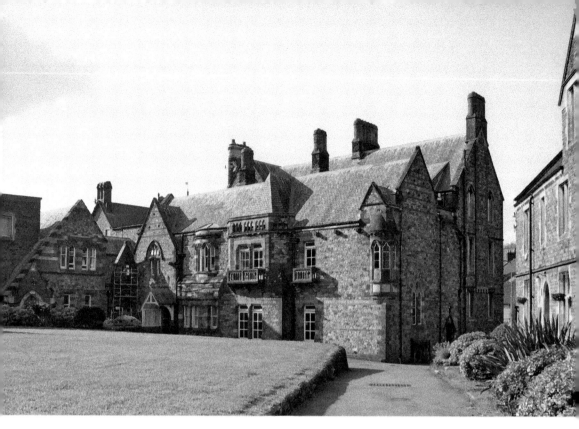

Above: Prichard's house, St Michael's' Theological College.

Right: Chapel at St Michael's Theological College.

placed windows, after the style of Le Corbusier's church at Ronchamp, France. Near the entrance, is a tooled-concrete cross, and above the entrance is a metal figure of St Michael by Frank Roper. The white-plastered interior, with its curved end walls and ceiling and its assemblage of assorted windows, has a special feel that is appropriate for a religious building. A metal and glass sculpture by Harry Stammers of Christ in Majesty hovers above a freestanding altar.

South: Cardiff Moors

43. The Pumping Station, Penarth Road

The colourful yellow and red building beside the Ely River was built in 1899 as a sewage pumping station and converted to use as an antiques warehouse around 1990. Designed by the borough engineer William Harpur, it comprises a large seven-bay main hall with two smaller wings at right angles, all with slate roofs and upstanding roof light-cum-ventilators. The yellow-brick walls of the main hall have regularly spaced round-headed windows with red-brick arches along the long sides, and between them thin brick pilasters carried up as chimneys. The gable ends have mixtures of round-headed windows with red arches on two levels. The long walls of the smaller wings have similar arrangement of windows to the main hall, but with groups of high-level, narrow, stepped windows on the gable ends.

The industrial character of the interior is exemplified by the steel trusses that support the roof and by the continuous rooflights. The basement, reached by a wrought-iron staircase, has black brick flooring and brick arches, while the floor above is carried on iron beams supporting two rows of brick vaulting (now plastered over). With thirty-five or more traders, each with their own remodelled section or stall, it's not always possible to be aware of the building's historic features.

The Pumping Station.

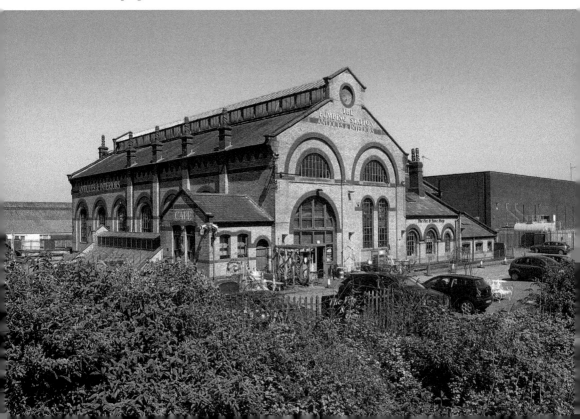

44. International Pool, Olympian Way

The swimming pool, designed by S. & P. Architects and opened in 2008, was the first building to be erected in the International Sports Village bordering the River Ely, near to its outlet into Cardiff Bay. Elliptical on plan with a flattish roof, the building is fully glazed and almost featureless apart from a sharply cut-back end near the road, where the roof, supported on round steel columns, overhangs a paved terrace that acts as an external viewing platform. The glass entrance cubicle is midway along the north-west side. The glazing is generally transparent, enabling viewers to see into the building from the encircling ramp, except in limited areas where light blue and light green glass is used instead.

Inside, the building is divided into three sections. The main, Olympic-sized, ten-lane swimming pool with raised seating for a thousand spectators occupies the area nearest the main road. At the opposite end is a large waterpark with flume rides and water slides; the centre portion is occupied by a reception, café, specialist facilities and mechanical apparatus.

The bullishly named International Sports Village occupies the former site of the massed railway sidings and coal-tipping jetties of the former Penarth Harbour & Dock Railway. Since the demise of the coal industry and removal of some of the River Ely's elaborate meanders the area has been transformed by construction of the International Pool, a rather mundane-looking White Water canoe centre (opened in 2010), and the tilted metal walls of the angular Ice Arena Wales ice rink (opened in 2016). The International Sports Village also includes large areas of residential and retail developments.

International Swimming Pool.

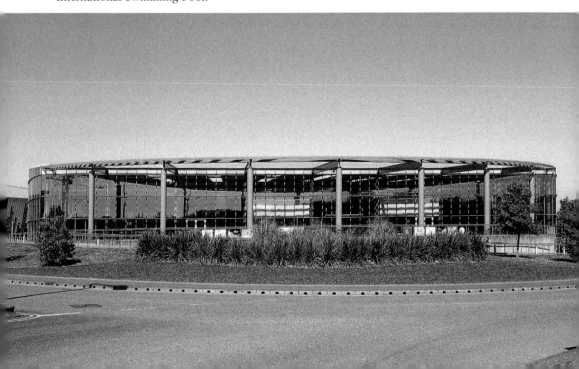

East: Roath and Heath

45. St Margaret of Antioch Church, Waterloo Road, Roath

A small medieval church survived here until the nineteenth century. Attached to it on the north side of the chancel was a mausoleum, which had been built in 1800 to hold the coffins of the Bute family. By the mid-nineteenth century the church had become inadequate for the parish's growing population and it was demolished in 1867 to make way for a new church, leaving the mausoleum standing.

Foundations for the new church were laid out by Alexander Roos, mostly along the lines of the old building. When, however, the young 3rd Marquess of Bute came of age in the same year, he dismissed Roos and commissioned John Prichard to provide a new design based on Roos's foundations. Prichard's design for the cruciform church included a tower with a spire, but these were not built for lack of money. The simplified tower by John Coates Carter, but without a spire, was added in 1926 as a First World War memorial. From the outside the church appears squat and, lacking the spire intended by Prichard, perhaps unexceptional.

The interior, by contrast, is an astonishing display of polychromatic surfaces with walls of light-coloured brick enlivened by black-and-red diaper work and piers of cream and pink sandstone alternating with bold bands of alabaster from Penarth. Windows appear to be relatively few, giving the interior a mellow and seemingly age-old atmosphere enriched by fine stained glass and a rich foliage carving. The glass

St Margaret's Church.

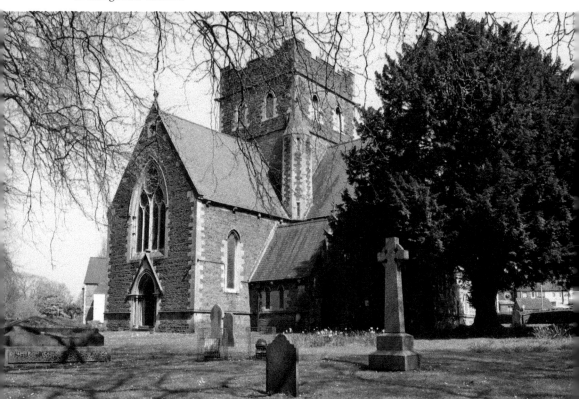

of the east window, showing the Ascension, was replaced in 1952 following a bomb blast. The reredos by Sir Ninian Comper was installed in 1925.

The old mausoleum that was incorporated into the new church, wedged between the chancel and north transept, was rebuilt between 1881 and 1886 to Prichard's design. This included a quadripartite rib-vaulted roof constructed with red and white bricks and a floor of black and white mosaic. The mausoleum houses an extraordinary collection of tombs – six massively large, and one small – made of polished, rose-coloured granite with chamfered edges to the 'lids'. The mausoleum is surrounded by a gilded wrought-iron screen.

46. Carnegie Library, Whitchurch Road, Heath

Designed in Arts and Crafts style by local architects Speir & Beavan, winners of a competition in 1906, this is one of two Carnegie libraries financed by the US businessman Andrew Carnegie, which were erected at around the same time. Sited fan-wise at the junction of two roads, it was built to a 'butterfly' plan with identical wings joined by a low entrance vestibule with a central turret and spire. The two lofty, church-like wings were originally intended as separate 'reading' and 'lending' rooms. They are lit by tall, narrow windows on the long sides and large four-light windows in Perpendicular style at the gable ends. The sides of the wings are mostly of Pennant sandstone with windows framed in Bath stone, while the gable ends and entrance block are mostly of Bath stone.

Carnegie Library.

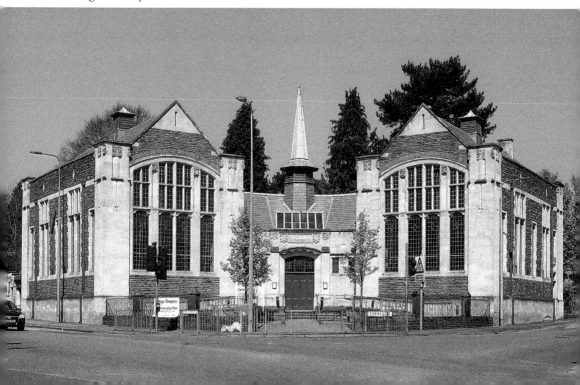

47. The Scott Memorial, Roath Park

The white clock tower in the shape of a lighthouse at the southern end of the lake in Roath Park was erected in 1915 as a memorial to Captain R. F. Scott and his companions. They had sailed in the SS *Terra Nova* from Cardiff 's Roath Dock on 15 June 1910 on a voyage to Antarctica, in order to locate the South Pole. Among Scott's companions was Petty Officer Edgar Evans from Rhosili, Gower. He was a member of the five-man team that reached the South Pole, all of whom died from frostbite and exhaustion on their way back. The close association between the city and the expedition resulted in the people of Cardiff collecting £2,500 (out of total subscriptions nationally of £14,000) towards the cost of the expedition. Before the ship's departure a farewell dinner for the expedition's members was hosted by the Cardiff Chamber of Commerce and there was a reception by the lord mayor.

On the expedition's return to Britain in June 1913, the ship was returned to its former owner, Bowring Brothers of Liverpool, who presented Cardiff with the ship's figurehead. This was displayed in Roath Park for a number of years before being donated to the National Museum of Wales. Mr F. C. Bowring donated money for the clock tower as a permanent memorial to Scott and the British Antarctic expedition. The tower has an encompassing balcony around the clock lantern, above which is a model of the SS *Terra Nova*. The lake had to be drained before laying the foundations of the tower, which cost £159 to construct.

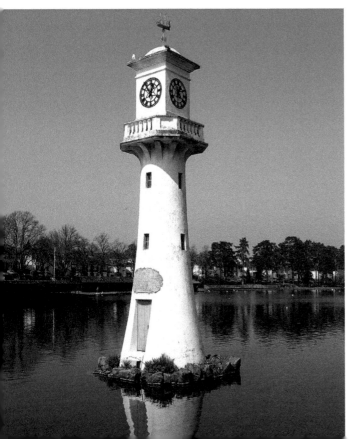

The Scott Memorial.

West: St Fagans

48. St Fagans Castle

The many-gabled, white two-storey manor house stands within the stout thirteenth-century curtain walls of a medieval castle. The house itself was begun in 1580 for Dr Gibson, a local lawyer. It and the estate were bought by Edward Lewis of Y Fan, Caerphilly, in 1616, and in 1730 Elizabeth, the Lewis heiress, married the 3rd Earl of Plymouth. Thereafter the house and estate remained with the Plymouth family until 1946 when the Earl of Plymouth donated them to the National Museum of Wales as a base for a national folk museum (*see* No. 49).

Externally, the house is notable for the perfect symmetry of the entrance front where projecting wings at each end and a two-storey gabled porch at the centre give the house an E-shaped plan. Large, four-light mullioned windows light the ground and first floors; the second floor, behind the precise gables, is lit by smaller windows. The west front, overlooking the gardens, shows the effect of irregular development during different stages of the house's history.

The interior followed the traditional hall house layout with the wood-panelled hall and wood-panelled withdrawing room on one side of a central screens passage (cross-passage) and the buttery and kitchen on the other side. The floor level of the latter is noticeably lower than the floors of the main rooms, so that the high-level windows needed for good ventilation in the kitchen do not spoil the symmetry of the exterior. The main staircase (installed in 1852–60) leads to a Long Gallery and Great Chamber on the first floor. The house is lavishly furnished to reflect family life during the late nineteenth century, as well as the house's history over four centuries.

To the west of the house a series of terraced gardens step down to a line of five nineteenth-century rectangular fishponds. On the north side, at the same level as the house, there are a number of formal gardens, including a Dutch garden, Italian garden, flower garden and knot garden.

St Fagans Castle, entrance front.

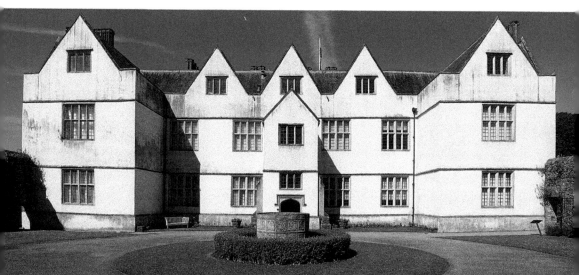

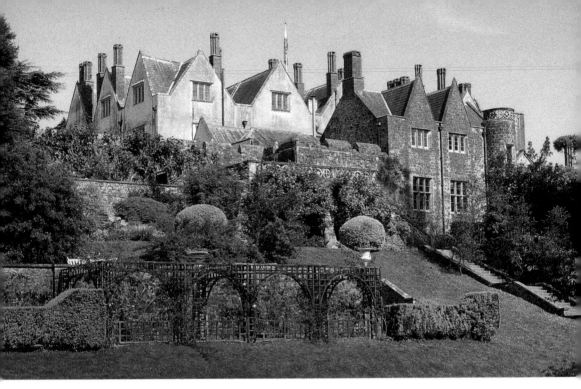

St Fagans Castle, garden front.

49. National Museum of History, St Fagans

The main entrance to the museum is reached from the road below St Fagans Castle. The entry building and galleries, designed by the author while on the staff of Sir Percy Thomas & Son, was planned around two rectangular courtyards and erected in two phases, opening in 1968 and 1972. Major alterations were made to the interior in 2017 by the architects Purcell; these included roofing over the larger courtyard, erecting two new exhibition galleries in place of two of the original galleries and providing extensive educational facilities. As the building had been listed as 'one of the foremost essays in pure modernism in Wales', the original main façade on the entrance side was retained.

The open-air section was laid out on the 42 hectares of parkland and woodland that had been generously donated to the National Museum of Wales by the Earl of Plymouth in 1946 for the creation of an open-air folk museum that would give 'as complete a picture of the Welsh past as possible'. Following principles laid down by earlier folk museums in Scandinavia – such as those in Stockholm (1891), Copenhagen (1897), Oslo (1902) and Helsinki (1909) – vernacular buildings from all parts of Wales have been re-erected and furnished in keeping with their time and place. Together, the buildings and exhibits in the museum galleries illustrate the traditional life and culture of Welsh society – both agricultural and industrial.

Today there are more than thirty vernacular buildings (mostly built in stone) that have been carefully dismantled at their original sites and painstakingly

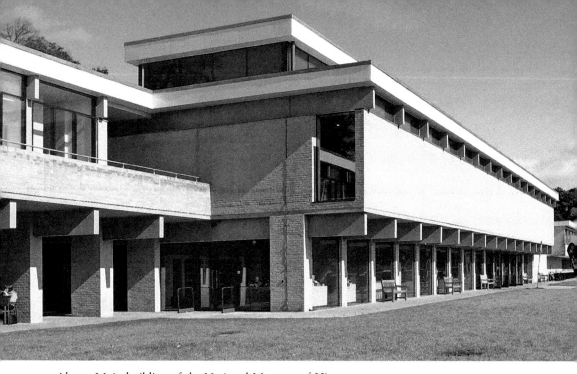

Above: Main building of the National Museum of History.

Below: St Teilo's Church, National Museum of History. Nave interior with replicated wall paintings.

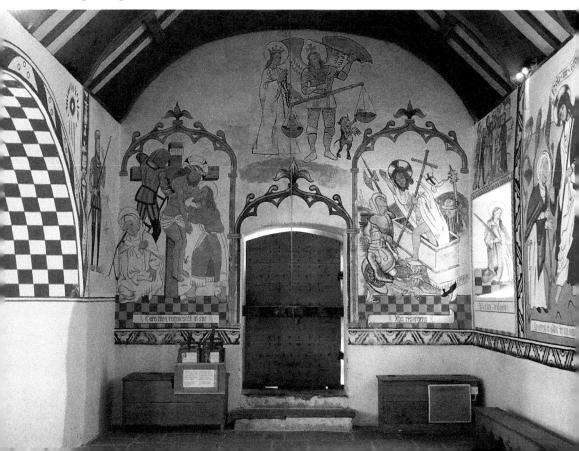

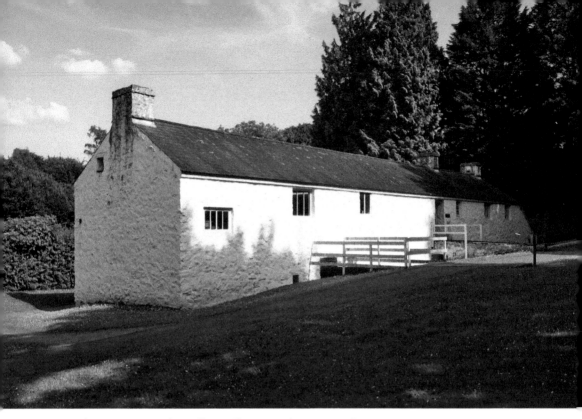

Above: Esgair-moel Woollen Mill, National Museum of History.

Below: Abernodwydd farmhouse, National Museum of History.

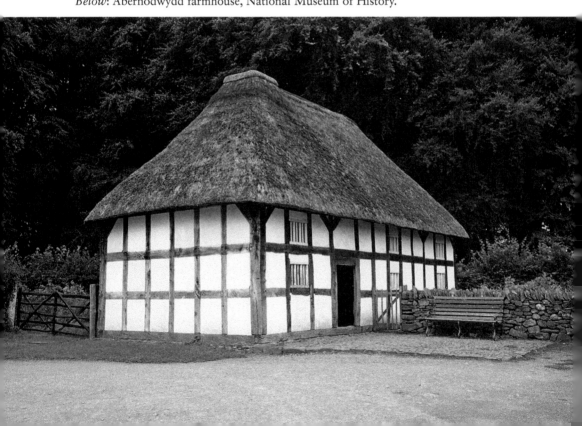

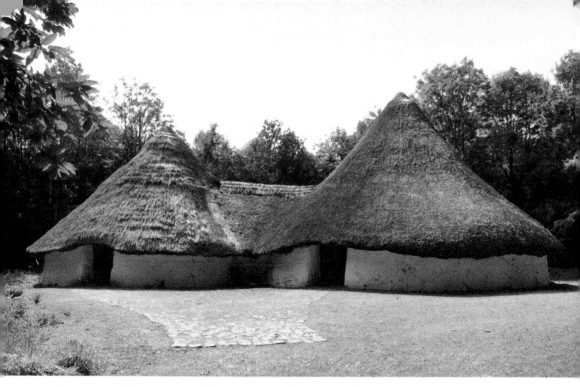

Reconstructed Iron Age roundhouses, National Museum of History.

re-erected in the open-air park. They date from the fourteenth century to the twentieth century, and include a medieval church (St Teilo's, with replicated wall paintings from the sixteenth century), an eighteenth-century woollen mill, and a seventeenth- or eighteenth-century farmhouse.

In addition, there are a number of reconstructions such as the Iron Age roundhouses and a prince's court from the twelfth century – both based on archaeological excavations.

North: Tongwynlais

50. Castell Coch

The fairy-tale castle overlooking the Taff Gorge on the northern outskirts of Cardiff is, despite its outward appearance, as much the work of the nineteenth century as the medieval period. It is possible that the first masonry castle – resting on an earlier earthen motte – was built by a Welsh lord of Senghenydd during the twelfth century. The surviving thirteenth-century masonry, however, is clearly Anglo-Norman work.

By the early 1870s, when the 3rd Marquess of Bute brought William Burges in to restore the triple-towered castle, it was in a completely ruinous state with little more than the upstanding remains of a couple of towers, a hall block and part of the curved curtain wall. Of the third, Kitchen Tower, there were little more than the foundations. Burges began the restoration in 1875, making a serious attempt

Castell Coch, from the River Taff.

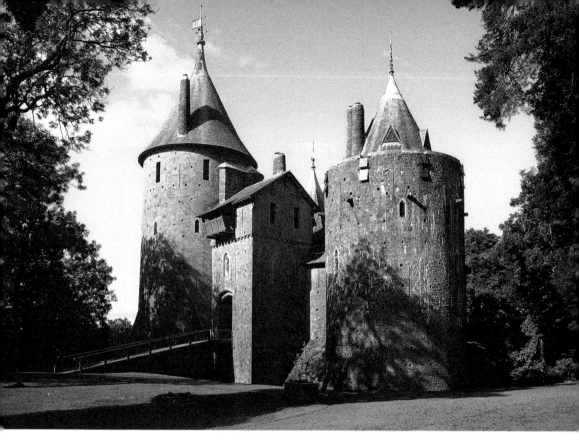

Keep Tower, entrance gateway and Well Tower, Castell Coch.

to reconstruct the castle as it might have once looked – at least externally – complete with a working portcullis and drawbridge. Influenced by French military architecture, the flamboyant chimneys and steep conical roofs to the towers are more continental in appearance than either Anglo-Norman or Welsh. Burges rebuilt the upper parts of two of the towers and built the Kitchen Tower from the foundations as the tallest of the three towers. He also rebuilt the curved curtain wall, adding an encircling gallery, and raised the hall block.

For the interiors, Burges indulged in a sumptuous extravaganza of Victorian decoration and invention, only equaled by his work at Cardiff Castle (*see* No. 2). The Banqueting Hall, located between the Keep Tower and the Kitchen Tower, is comparatively restrained, the main features being an elaborately carved stone chimney piece containing a sculptured figure of St Lucius and a handsome tie-beam roof.

In the octagonal Drawing Room there was no restraint. Two storeys high with an encircling gallery and a wonderful rib-vaulted ceiling, it is profusely decorated throughout, with plants and scenes from *Aesop's Fables* on the walls, birds on the ceiling panels, and carved butterflies on the vaulting ribs. Lady Butes' bedroom, occupying the upper floors of the Keep Tower, has decoration with a mixture of Oriental features and paintings and carvings derived from medieval illuminated manuscripts. It has another typically Burges chimney piece, Gothic arcading and an extraordinary coffered, double-dome ceiling.

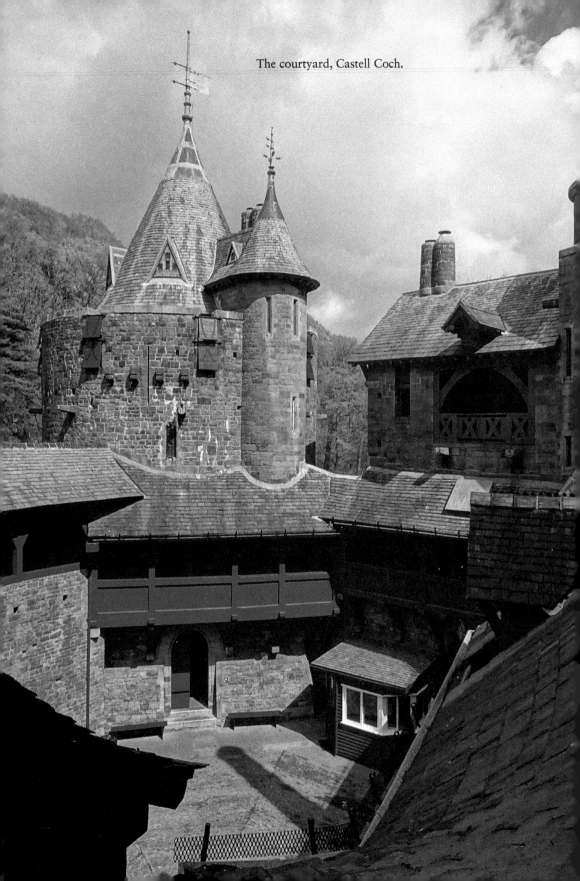

The courtyard, Castell Coch.

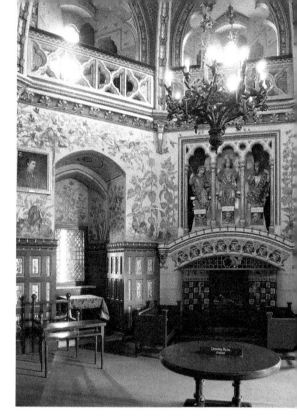

Right: Castell Coch, Drawing Room.

Below: Lady Bute's bedroom ceiling, Castell Coch.

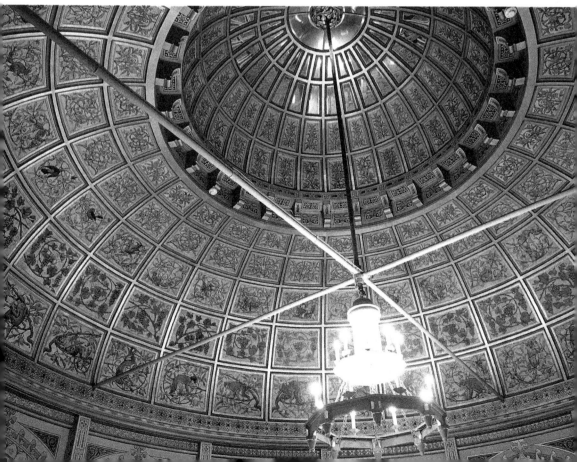

About the Authors

John Hilling wrote the text for this book. Before retiring he worked as an architect and town planner in London, Gwynedd, Edinburgh and Cardiff. His career has included urban and rural planning, residential and civic buildings and the restoration of ancient monuments. He lives in Cardiff and is the author of ten published books, including *Cardiff and the Valleys* (1973), *The History and Architecture of Cardiff Civic Centre* (2016), and *The Architecture of Wales* (2018).

David Hilling was born in Bangor, North Wales, but has lived most of his life in Cardiff. He qualified as a graphic designer in 1983 and currently runs his own business: dh Graphics (dhgraphicswales.co.uk). He has contributed numerous maps and plans to several books, including *The History and Architecture of Cardiff Civic Centre* (2016), and *The Architecture of Wales* (2018) as well as photography for *Changing Cardiff* (2012). David has taken the photographs for this book.